IMAGES
of America

KEENE

IMAGES
of America

KEENE

Drawn from the collections of the
Historical Society of Cheshire County
Keene, New Hampshire

Alan F. Rumrill

ARCADIA
PUBLISHING

Copyright © 1995 by Alan F. Rumrill
ISBN 978-0-7385-6555-2

Published by Arcadia Publishing
Charleston, South Carolina

Printed in the United States of America

Library of Congress Catalog Card Number: 2009923303

For all general information contact Arcadia Publishing at:
Telephone 843-853-2070
Fax 843-853-0044
E-mail sales@arcadiapublishing.com
For customer service and orders:
Toll-Free 1-888-313-2665

Visit us on the Internet at www.arcadiapublishing.com

CONTENTS

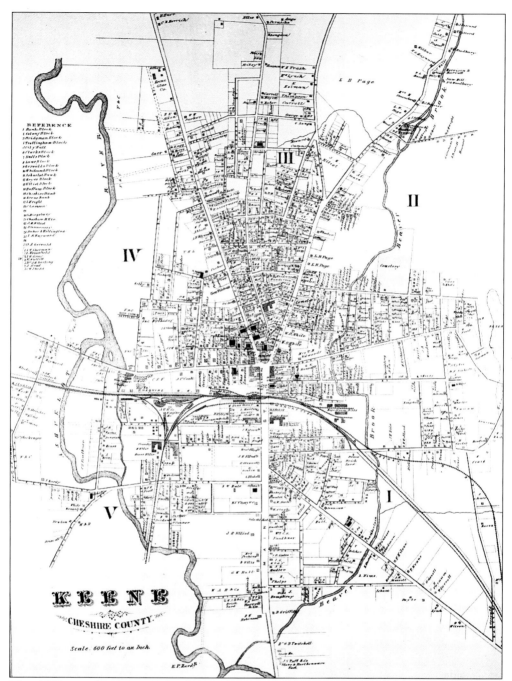

This 1877 map demonstrates the hub and spoke layout which Keene has had from its earliest days. Five major roadways radiated outward from Central Square. Residents from throughout the region traveled these roads to reach Keene's retail stores, industrial plants, and county offices. Many early water-powered mills were located along the Ashuelot River to the west and Beaver Brook to the east. The railroad reached Keene in 1848, bisecting the city just south of Central Square. Major industries then began to locate along the tracks. The growth that was stimulated by the railroad assured Keene's role as the economic hub of the region.

INTRODUCTION

One day in February of 1737 Nathan Blake and William Smeed strapped on their snowshoes and plodded away from Upper Ashuelot (as Keene was known then), hoping to traverse the deep snow for the 25 miles which lay between them and the nearest permanent settlement, Northfield on the Connecticut River to the south. These men had attempted to spend the winter at this new settlement in the wilderness, the first Europeans to try it; having exhausted their provisions during the unexpectedly harsh winter, they were forced to leave. They survived the trek south to Northfield and returned again in the spring to take up permanent settlement in the new village.

"Upper Ashuelot" is very different now, although some things have remained the same; the region can still have harsh winters, but Keene has grown to 22,000 residents. The town has experienced a varied and eventful history since Blake's and Smeed's abandonment 250 years ago.

Keene is located at the center of Cheshire County in the southwestern corner of New Hampshire. What led colonial surveyors and developers to choose this location in the wilderness for settlement in the 1730s? Undoubtedly, they recognized the geographic advantages of this area. The village was situated on the floor of a valley which once had been part of a large glacial lake. As a consequence, it had level terrain, rich sedimentary soil, and ample water from remaining streams for power, irrigation, and drinking. Finally, no Native Americans remained in the region when the first European settlers arrived, the result of epidemic and shifting tribal alliances in the previous century.

The town grew rapidly, harboring 750 residents by the onset of the Revolutionary War in 1775. "Upper Ashuelot " began as an agricultural community; as late as 1850 there were still 178 active farms in the town. Soon after the settlement, however, enterprising individuals began to take advantage of the power afforded by the Ashuelot River and numerous smaller streams. By 1800, two sawmills, two grist mills, a potash mill, fulling mill, and a distillery were operating in the town. Keene has enjoyed the benefits of a diverse industrial base ever since.

Keene was made shire town at the formation of Cheshire County in 1771. The county courthouse was located at the convergence of five roads from surrounding towns, an important confluence to be known as Central Square. Several stage lines were using these roads by the early 1800s, bringing travellers into the community. Fifteen stores and artisan's shops and the Phoenix Hotel had opened at Central Square by 1830 to serve these travellers, as well as the local residents; the Square became the heart of the village.

The arrival of the railroad at Keene in 1848 assured the town's role as the transportation and economic center of southwestern New Hampshire. The road offered transportation not only for people, but for raw materials and finished products of local industry. Firms located their factories and warehouses beside the tracks in Keene to take advantage of the railroad. More people moved into Keene to work at these factories. Consequently, more service and retail firms opened to serve the growing population. There were more than 6,000 residents in 1874, when Keene became a city.

Keene today, with a population of more than 22,000, remains the only city in the region, and continues as the economic hub of a much larger geographic area. The automobile has allowed residents of neighboring towns to commute to the city for work, trade, education, worship, and entertainment. The hills which ring the community have necessarily limited commercial development, but also provide a continuous reminder of Keene's rural setting even from downtown. The historic homes, wide Main Street, town common, and large white meetinghouse sustain a visible, historical link with the town's colonial heritage. Residents take pride in Keene's history and the accomplishments of the 250 years that have passed since Nathan Blake and William Smeed plodded through the snow to Northfield.

This book offers a visual record of life in Keene from 1859 to the 1950s. Since photography was only introduced in the nineteenth century, there is a large gap in what pictorial histories can cover. Photography was not introduced in Keene until more than one hundred years after the first European settlers began to clear the forest. Keene artisan Edward Poole built a camera around 1840 and the first local professional photographer, Norman Wilson, opened shop in 1842. However, other than a few portraits by Poole, there are few surviving photographs of the community taken prior to 1860. Consequently, a book of historical photographs such as this offers an incomplete view of local history. Furthermore, each photograph records not only what is happening, but what the person behind the lens has chosen to see. Thus, those scenes that were preserved on film were generally events or views that held significance for the community. A collection such as this will offer some sense of what has gone before, and how Keene got to where it is today.

The photographs in this book are from the collections of the Historical Society of Cheshire County, located at 246 Main Street in Keene. The Society's files contain approximately 10,000 Cheshire County photographs dating from the 1840s to the present. These views are the work of more than fifty professional and hundreds of amateur photographers. The committee that selected the photographs for this work focused not only on the best views of Keene, but gave priority to images which have not already had wide circulation.

The 10,000 photographs are only a small fraction of the 300,000 items in the collections of the Historical Society. These extensive archive and artifact collections are available for research purposes every weekday. In addition to research facilities, the organization operates the 1762 Wyman Tavern period house museum and offers a wide variety of educational activities. The Historical Society of Cheshire County, founded in 1927, is dedicated to collecting, preserving, and communicating the history of the region. The Society's board of trustees believes that this publication is one means of fulfilling that mission.

One

MAIN STREET AND CENTRAL SQUARE

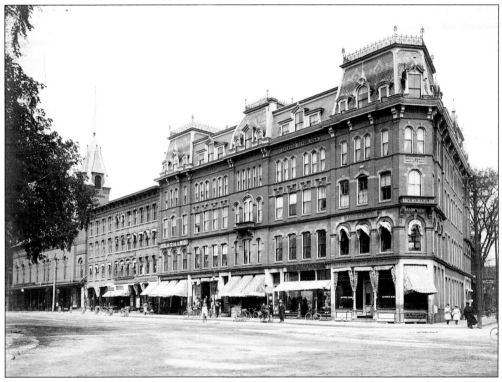

The east side of Central Square in about 1900. The mansard-topped Colony and Bank Blocks were built as a matching pair in 1870-71. City Hall is visible to the left. Main Street and Central Square had been the center of commercial activity in the community from the time of the first settlement in the 1700s. Central Square became the true heart of the community with the construction of the meetinghouse, courthouse, and town hall prior to 1800. The Square developed at the convergence of the five roads from surrounding towns. By 1830 fifteen stores and artisan's shops and a hotel had joined the meetinghouse and town hall around Central Square. More than half a dozen stage lines brought travellers, and customers for these businesses, into the village.

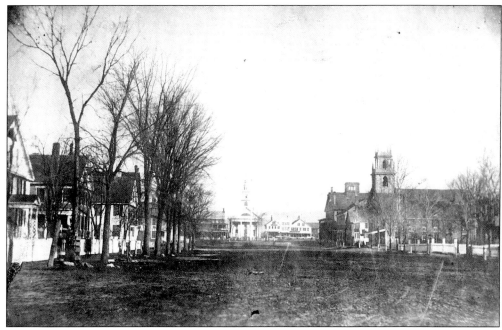

Main Street looking north to Central Square, c. 1859. This is probably the oldest photograph of Main Street. It shows the Congregational Church at the center and the Unitarian Church, on the corner of Church Street, to the right. The commercial center, while growing, was still quiet; but already Keene was becoming known for its uniquely wide Main Street.

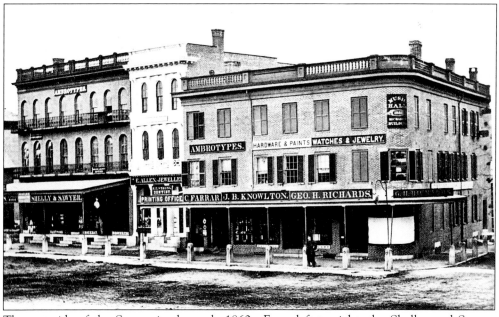

The east side of the Square in the early 1860s. From left to right, the Shelley and Sawyer Block, the Cheshire Mills building, and Richard's Block housed a wide variety of commercial establishments, illustrating the diversity of the Keene economy by the time of the Civil War. All of these buildings were destroyed by fire on October 19, 1865.

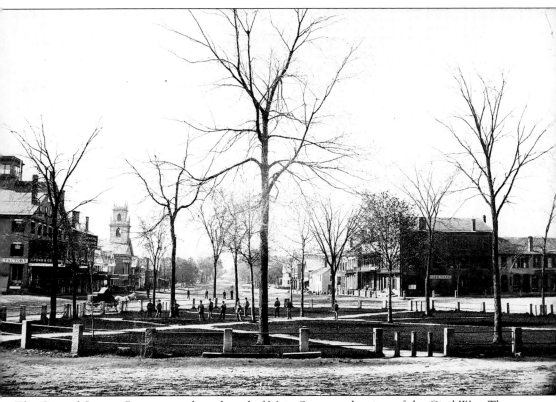

The Central Square Common and north end of Main Street at the time of the Civil War. The common, fenced in during the 1850s, had become a formal public park. Despite the existence of a large hotel (the Cheshire House to the extreme left), the railroad, and several business blocks at the head of Main Street, there is not visible a single moving vehicle—only several local fellows posing in the middle of the street for the photographer.

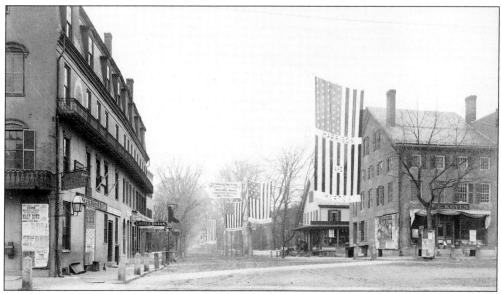

West Street from the Square during the presidential election campaign of 1888. Keene residents made their preferences known by the "Harrison and Morton" and "Cleveland and Thurman" banners overhanging the street into the distance. Keene's oldest surviving downtown block, the Elliot Block dating to 1815, is to the left.

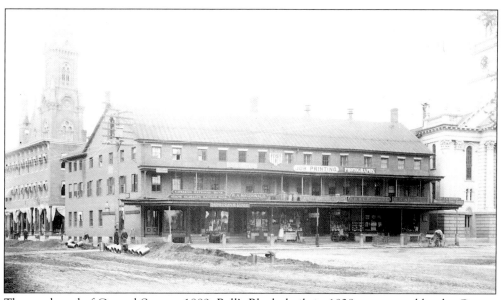

The north end of Central Square, 1889. Ball's Block, built in 1828, was owned by the George W. Ball family for more than fifty years, where they manufactured and sold hats and caps and took orders for building bricks made at their local brickyard. Workers can be seen extending the city sewer line.

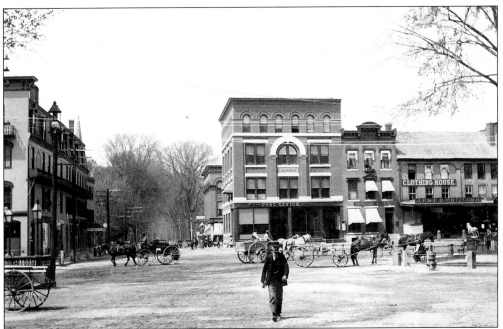

A busy day on the Square in May 1896. The post office had recently moved into the new four-story Russell Block on the corner of West Street. The Ashuelot Bank was located to the right of the post office. The Ashuelot was only one of seven Keene banks at that time. Although the city had only 9,000 residents, it had become the banking center for southwestern New Hampshire, reflecting Keene's pivotal role in the economic life of the region.

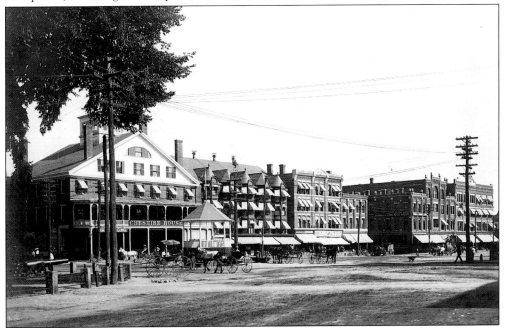

The east side of Main Street in about 1900. The Cheshire House Hotel, built in 1837, hosted presidents, actors, inventors, and countless other guests who partook of exotic specialties in its famed dining room. The hotel was demolished in 1934.

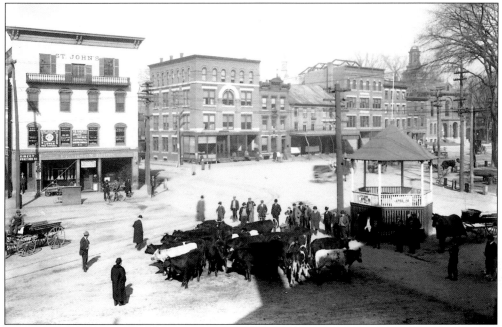

Cheshire Beef Company cattle on Main Street, April 13, 1911. Cattle were still herded through the street, despite increased trolley and auto traffic. Being a transportation hub meant that herds of animals would still be driven through Keene well into the twentieth century on their way to distant markets.

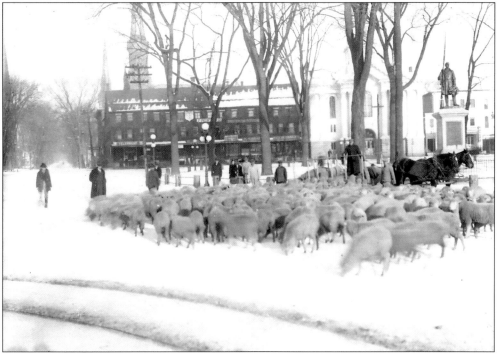

Sheep in the Square, c. 1910. Large numbers of sheep were pastured on the region's abandoned hill farms. Their wool was sold to the many local textile mills.

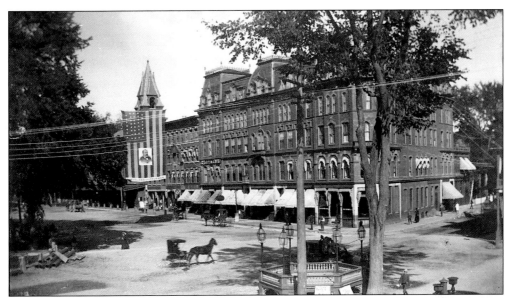

The east side of the Square, 1888. Notice the intrusions of technology in the form of gas lamps on the street and electric lines overhead. The bandstand and Walker Elm located in the middle of the street, however, suggest a slower pace of life.

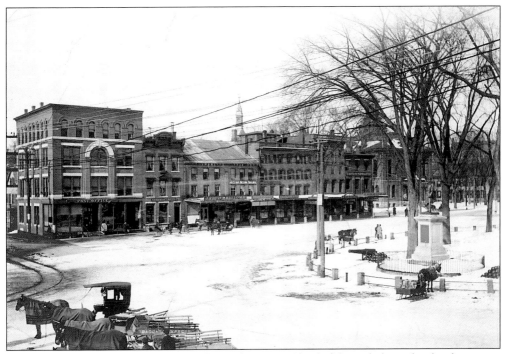

The west side of Central Square in the early 1900s. Sleighs abounded on this bright winter day. Howe's jewelry store and the Bullard & Shedd drugstore remain in business on the Square nearly a century later.

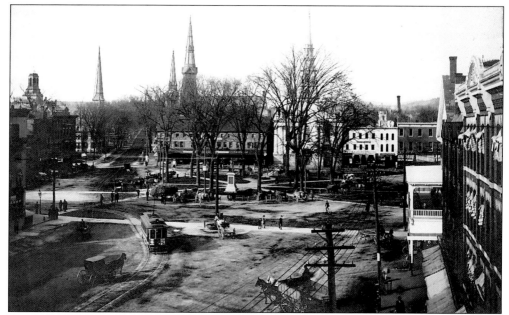

Freight wagons lined up around the common, *c*. 1905. A trolley was returning from its West Street run. Four prominent steeples atop the Methodist, Second Congregational, Baptist, and First Congregational Churches remind us that the Square has always been a hub of worship and faith, as well as of banking, trade, and government.

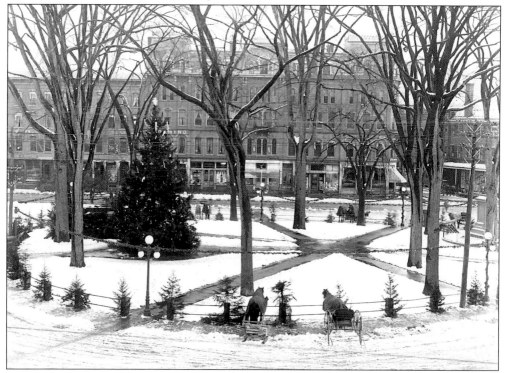

The common at Christmas time, 1913. The first municipal Christmas tree stood on the common as city government began a long tradition of involvement in this seasonal holiday.

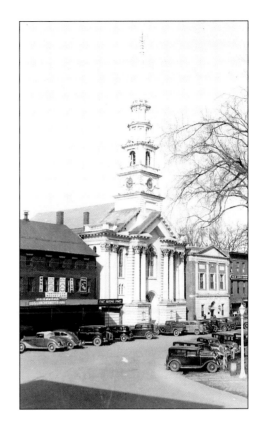

The First Congregational Church during the 1930s. Automobiles, now affordable to the average family, became an increasing presence on the Square, crowding the street and store fronts. The church was flanked by Emmond's Luncheonette, Vignealt's Melody Shop music store, the First National Store, and Keene National Bank.

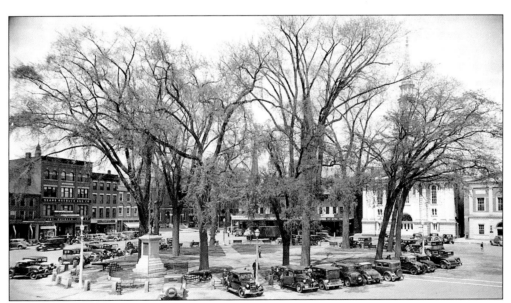

The Square in about 1938. The towering elms that encircled the common illustrate why Keene was known as the Elm City. Two national chain stores had made their appearance on the square: the First National Store and Sears Roebuck and Co.

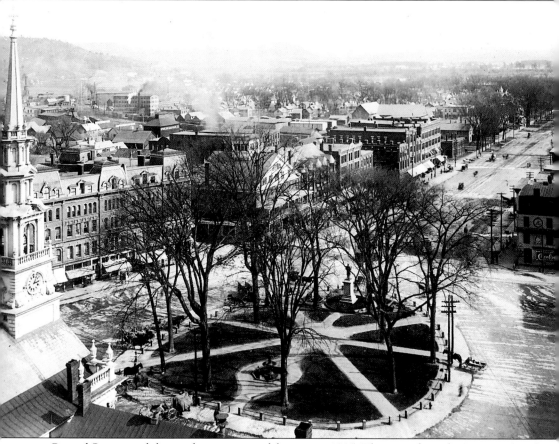

Central Square and the southeast corner of the city, c. 1905. This view from the Baptist Church steeple shows the east side industrial firms straddling the railroad tracks. These factories were set back from, but in close proximity to, Main Street, allowing employees to work, shop, and live within walking distance.

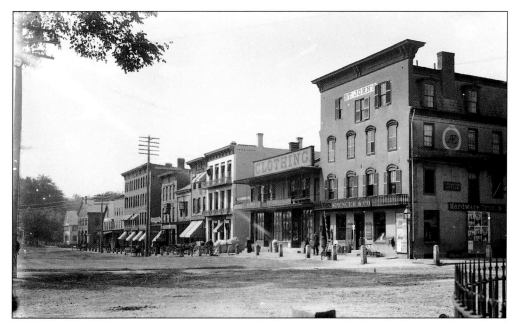

The west side of Main Street, c. 1890. Business blocks now extended south almost to the railroad station in the distance. Notice the initiative of the Spencer & Co. hardware store, setting out seasonal products to entice buyers.

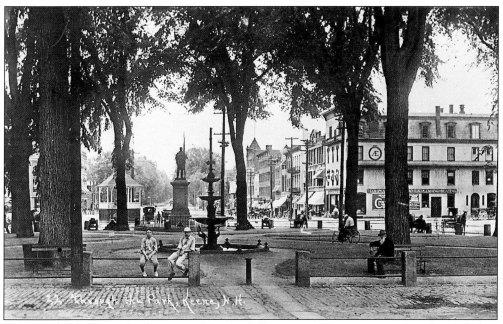

Young and old alike took advantage of the shaded common. This view was taken shortly before the removal in 1913 of the Ingersoll Fountain, in the center. The ornate Victorian fountain was donated to the city in 1896 by local philanthropist Caroline Haskell Ingersoll in memory of her brother Allan. The city had modernized the Square in 1910 by paving the roadway with brick.

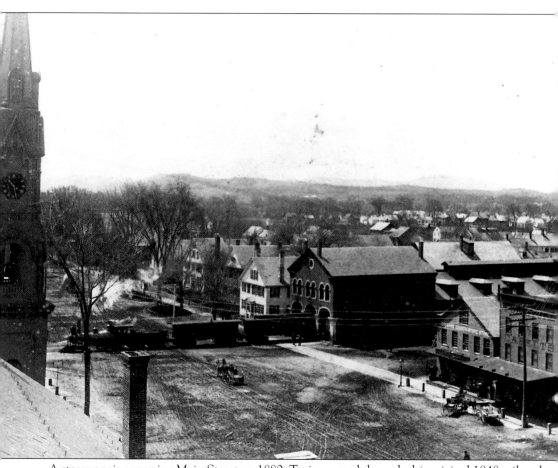

A steam engine crossing Main Street, c. 1880. Trains passed through this original 1848 railroad station until it was replaced in 1910 because the new trains did not fit through the old depot. This view shows some of the hills surrounding the flat valley on which Keene is located. The site of the city was once part of a large glacial lake.

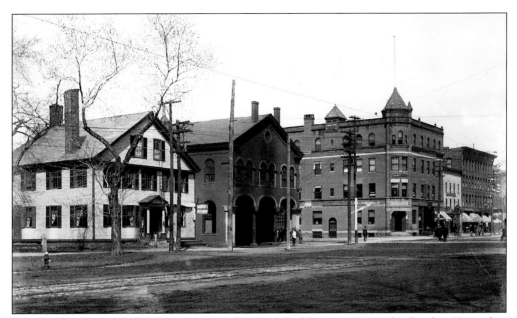

The Dunbar House, railroad station, and Sentinel Building, c. 1910. The Dunbar House has been a tavern and restaurant periodically since the eighteenth century, here housing Marrion's Restaurant, and subsequently Henry David's restaurant. This name stems from the fact that Henry David Thoreau's mother, Cynthia Dunbar, was born in the house in 1787. The 1893 Sentinel Building was constructed as the home of the *Keene Sentinel*, one of the nation's oldest continuous newspapers, first established in 1799.

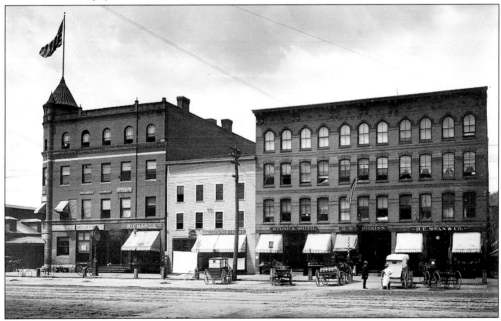

Delivery wagons parked along the west side of Main Street during the second decade of the twentieth century. The turreted Sentinel Building was adjoined by the Bruder and Lamson Blocks. The variety of retail firms and professional offices along Main Street show the diversification of Keene's economy.

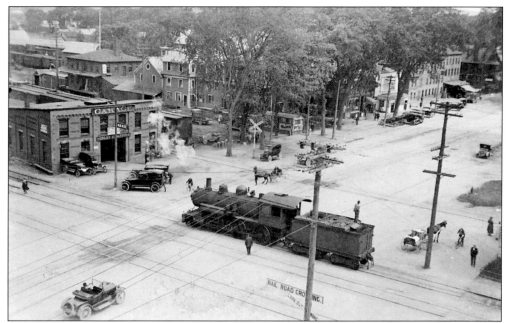

The busy Main Street rail crossing in the 1920s. The Boston & Maine Railroad and Keene Electric Railway tracks intersected at the heart of the city. Perley Safford's Garage catered to the owners of automobiles, which far outnumbered horse-drawn wagons in this view.

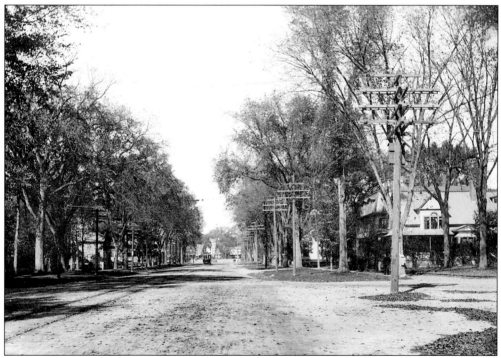

Looking north from the corner of Marlboro Street, c. 1915. The lower end of Main Street was still predominantly residential. The slow-moving trolley was overshadowed by the stately elms lining the street.

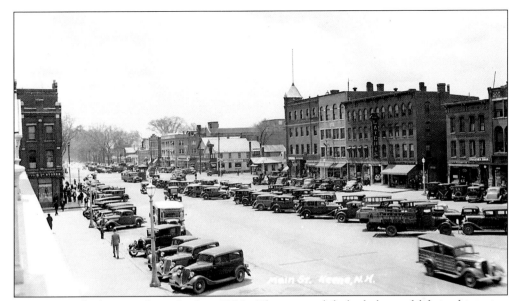

Main Street looking south in the late 1930s. The automobile had changed life in the region and across the nation. More than one hundred autos crowded the street on this day. Buses had replaced the electric trolley as the local form of public transportation in 1929, offering a flexibility in routes much as trucks did when they supplanted railroads in the 1980s.

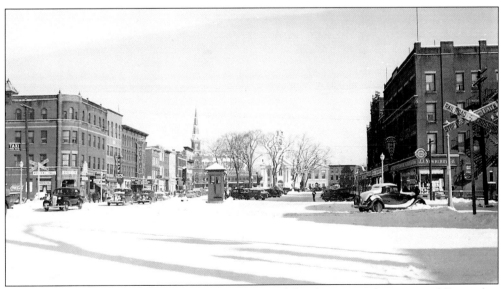

Main Street during the winter of 1938–39. Traces of the devastating hurricane of September 1938 are still visible; the steeple of the Congregational Church had not yet been replaced. The railroad signal man can be seen in his booth at the Main Street crossing, where he assisted trains across the busy street.

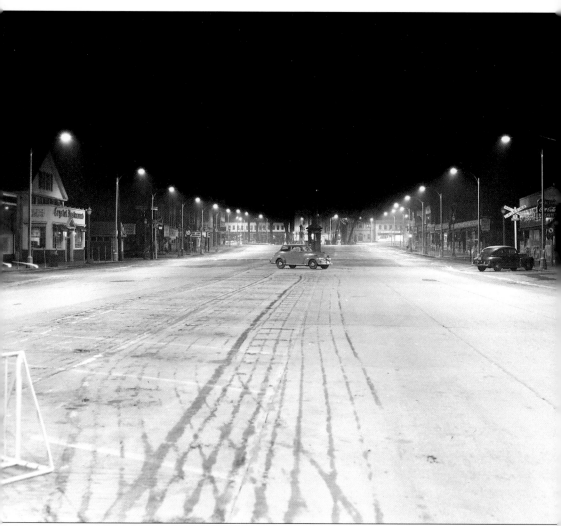

Mercury vapor street lights transformed night into day when they were installed on Main Street in 1953. This 4:20 am view shows a deserted downtown. Long-time Main Street businesses such as the Monadnock Grill, Crystal and Bon Ton restaurants, and Fishman's, Newberry's, and Woolworth's department stores would unlock their doors in a few hours. The national entertainment industry had a Main Street presence by this time: Clark Gable was appearing in *Mogambo* at the Latchis Theatre.

Two

WORK AND WORKERS, BUSINESS AND INDUSTRY

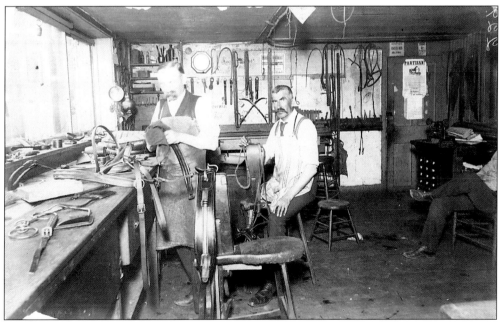

Otis Howard at work in his harness shop at the Ellis Hotel in 1891 or 1892. Keene has benefitted from a diverse industrial base for two centuries. Among the more significant manufactures of the city have been glass, pottery, shoes, toys, textiles, machinery, rocking chairs, optical instruments, and a wide variety of woodenware. In turn, other commercial enterprises grew to serve the employees of these factories and those people coming into Keene by stage, rail, and auto. The employees of all of these firms built the city of Keene, literally and figuratively.

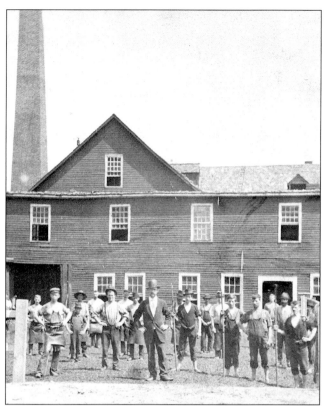

Foster's Tannery on Beaver Street. Owner Frank Foster is in the top hat at the center of this late-1870s view. Foster's and several other large tanneries prepared leather for businesses such as Howard's harness shop. Tanneries were offensive but essential local enterprises in the day of horse-drawn transportation.

Enos Holbrook's grist mill on East Surry Road. Saw and grist mills were the first manufactories to be built because of the need for lumber for houses and meal for food. Holbrook built his mill in about 1787. Powered by outflow from Goose Pond, it operated until 1869 when the town of Keene purchased the water rights to the pond to construct a water system into the village.

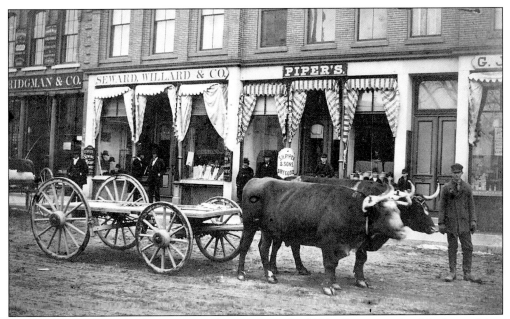

Young Mr. Nims brought his team into downtown in the 1880s. Oxen were used for heavy labor on the farm and in the forest before mechanization.

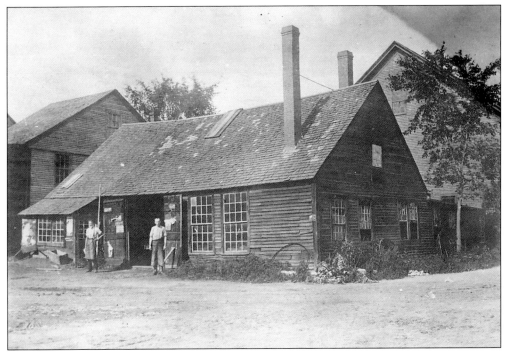

The J&F French blacksmith shop between Railroad and Church Streets, prior to 1897. Blacksmiths were also indispensable to the transportation industry, producing horseshoes, sleigh runners, and wheel rims. The J&F French company was a leading sleigh manufacturer.

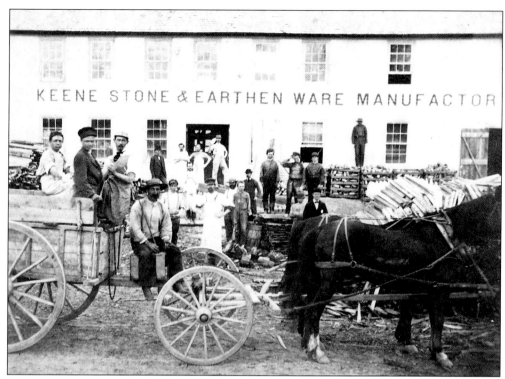

The Keene Stone and Earthen Ware Manufactory on Myrtle Street. Keene's alluvial soils have long been exploited for ceramics and brick manufacture. This shop produced pottery from 1871 to 1874, when James S. Taft of the Hampshire Pottery Company (lower Main Street) bought it at auction.

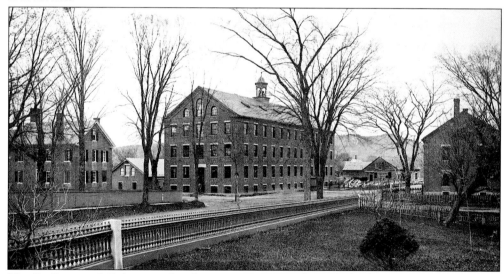

The Faulkner and Colony woolen factory as it appeared in 1885. This West Street firm was central to Keene's history and economy for almost 150 years. The Faulkner and Colony families became business, social, and political leaders of the community. Their successful business, founded in 1815, provided employment to thousands of textile workers as well as ensuring markets to the region's sheep herders.

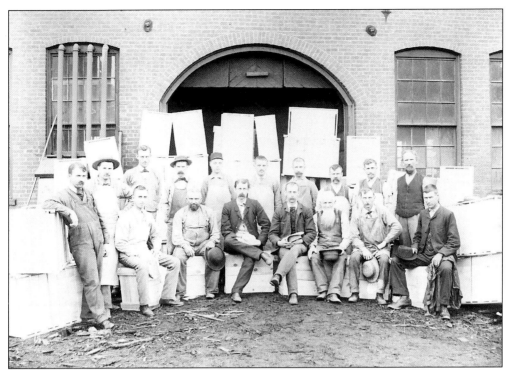

Employees of the J. Mason Reed Company, makers of locked corner boxes, pose with their products. This was one of dozens of firms that took advantage of the region's most plentiful natural resource—its forests. J. Mason Reed operated in Keene from 1881 to 1912, during a time when southwestern New Hampshire was the center of New England's wooden packaging industry.

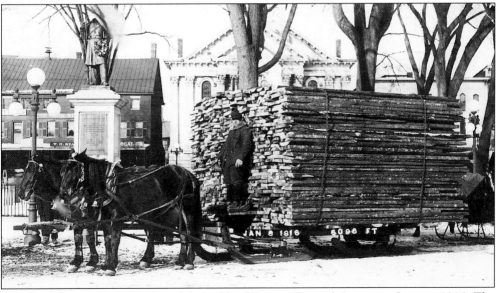

Robert Blake sledded 6,096 board feet of lumber into Central Square in January 1916. The county's hill farms had reverted to forest by this time creating a ready resource for timber men and portable sawmills.

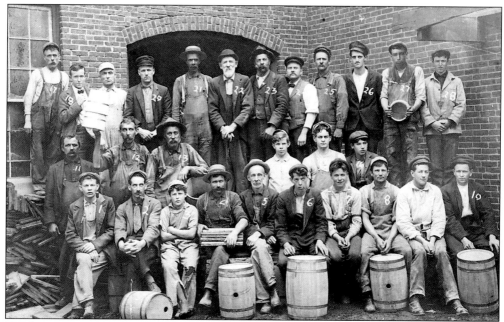

Employees of the Impervious Package Company in the early 1900s. Impervious Package operated from 1881 to 1928. It produced leakproof containers for paints, oils, and other liquids.

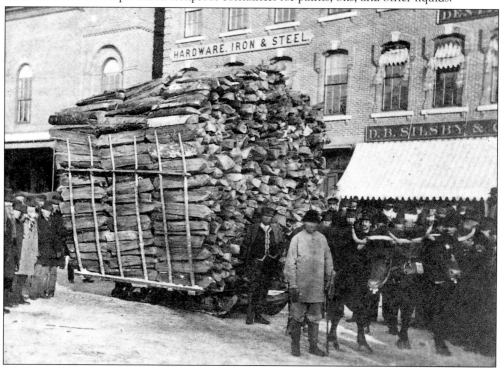

The "Champion Load of Wood," February 1875. Roswell Nims of Sullivan drew this load of 114 cords into the city for sale to the Cheshire Railroad Company. Manufactories using kilns (such as potteries and brickyards) and railroads (which fired locomotives with wood) were large consumers of wood in the area.

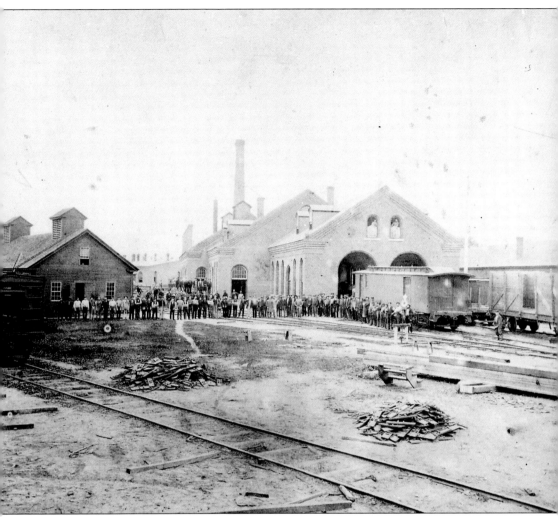

Cheshire Railroad repair shops, c. 1890. The railroad had reached Keene in 1848, and in 1866 the Cheshire Railroad company opened these shops, served by a turntable. They were soon building cars and began building entire locomotives in 1868. By 1878 there were tracks running out of Keene in four directions. The town became the rail center and, consequently, the industrial and retail center of a large geographic area. By 1890 the Cheshire Railroad employed 250 people; more than 100 posed for this photograph. The railroad was the single greatest factor in Keene's economic development.

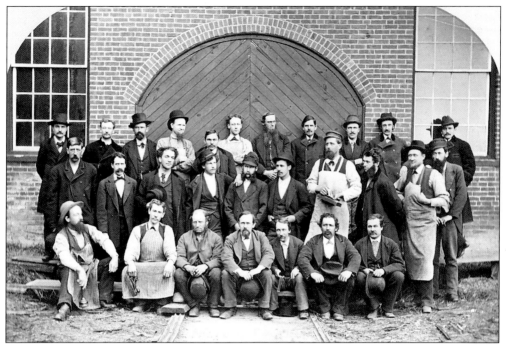

A Cheshire Railroad carpentry shop crew. These men kept the trains rolling. They built and repaired rail cars in the Cheshire shops during the latter part of the nineteenth century.

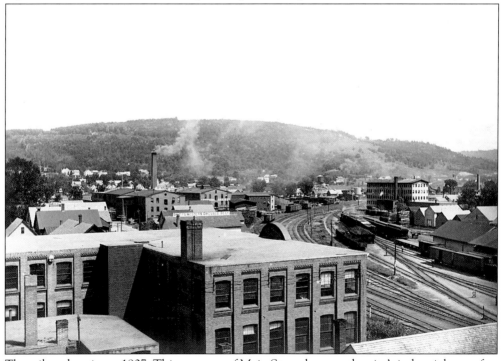

The rail yards, prior to 1907. This area east of Main Street became the city's industrial core after the Civil War. Manufacturers of shoes, silverware, chairs, toys, and many other products built near the tracks for access to rail transportation of raw materials and finished products.

Stephen K. Stone's milk farm, Leverett Street, during the 1890s. Mr. Stone, to the right, posed in top hat and coat, with milk bottle in hand. Keene retained aspects of its agricultural origins well into the industrial era. Stone's was one of nine commercial dairies operating in town in the 1890s.

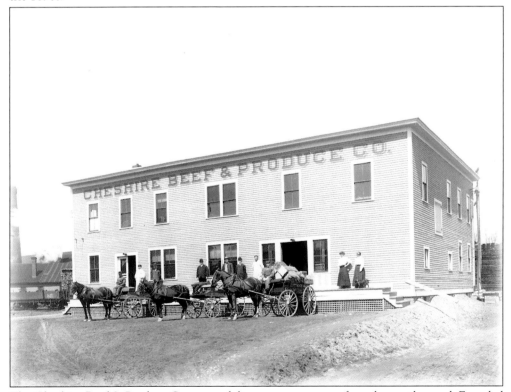

The Cheshire Beef & Produce Company delivery crew prepares for a day on the road. Founded by William Coughlin and John Hovey in 1894, this firm was a wholesaler of beef, pork, lamb, tripe, and tongue. The business survived into the 1930s.

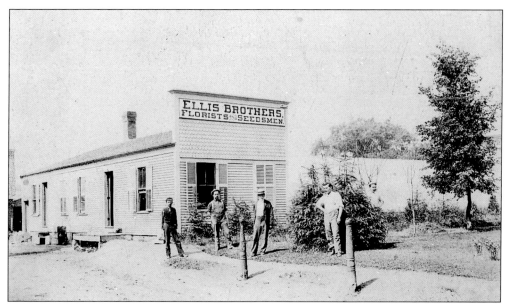

The Ellis Brothers Florists and Seedmen store and greenhouse on Winchester Street at the end of the nineteenth century. Albert and Marcus Ellis began the firm in 1873 on land adjacent to their family's iron foundry. They advertised shrubs, roses, bulbs, seeds, flowers, wreaths, and bedding plants. The firm remained in business for almost one hundred years.

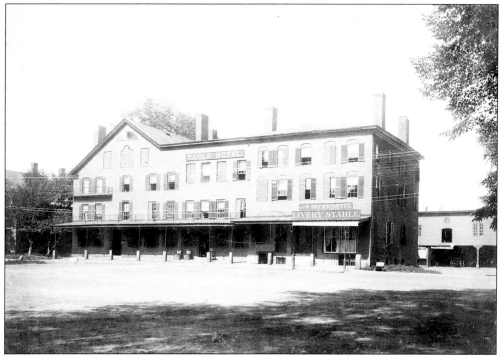

The Eagle Hotel, Main Street. The Eagle, shown here in 1900, was the oldest of Keene's three downtown hotels. It opened in 1806 and continued in business until 1952. The building was destroyed by fire in 1968. Today's hotels and motels are located on the outskirts of the city because most travelers bypass the downtown on the relocated state highways.

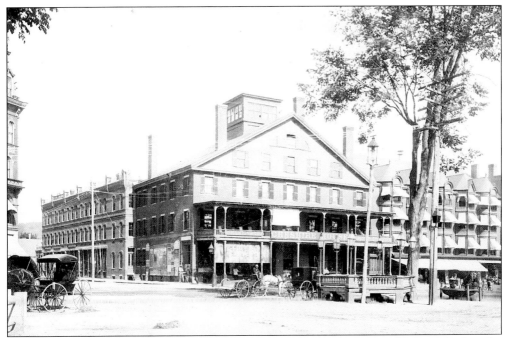

The Cheshire House, Keene's best known hostelry, as it appeared in 1900. This hotel, built at the corner of Roxbury and Main Streets in 1837, was known far and wide. It hosted such dignitaries as Thomas Edison, Henry Ford, Harvey Firestone, General Tom Thumb, and Presidents Taft and Coolidge. The Cheshire House breakfast menu was described as the longest in the world. Some of the more exotic dishes included lamb's tongue, green turtle soup, fried calf's brains, and fried bananas. The building was razed in 1934.

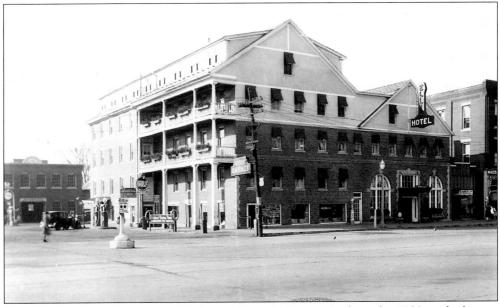

The Ellis Hotel, at the corner of Main and Emerald Streets. Built in the 1830s, it had many proprietors and many names during its 140 year history. It was the last of the three downtown hotels to survive, finally falling to bulldozers in 1972.

35

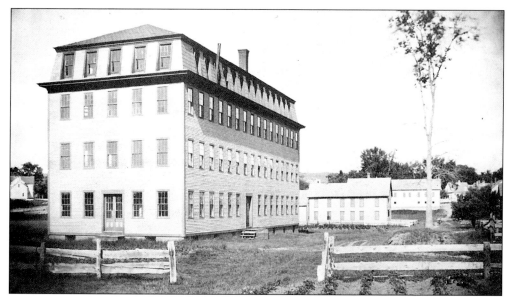

The Ashuelot Boot and Shoe Shop, Leverett Street. This neat mansard-style factory building was one of many large Keene shoe producers. This plant was built north of downtown in a field alongside the Ashuelot River. The company did not survive the destruction of the factory by fire in 1881.

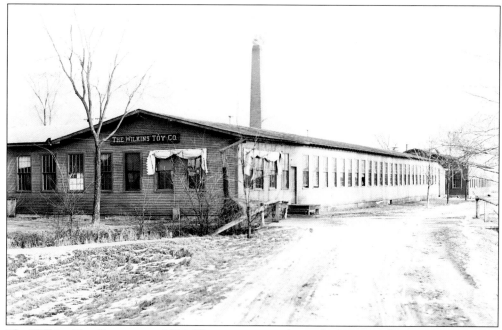

The Wilkins Toy Company in 1900. The company was begun by James Wilkins in about 1890. It was soon purchased by Harry T. Kingsbury and continued as the Kingsbury Toy Company. The company produced a wide variety of metal wagons, trains, boats, autos, trucks, and airplanes. The firm transferred all production to machine tools in the 1940s and continues in that line today as the Kingsbury Corporation.

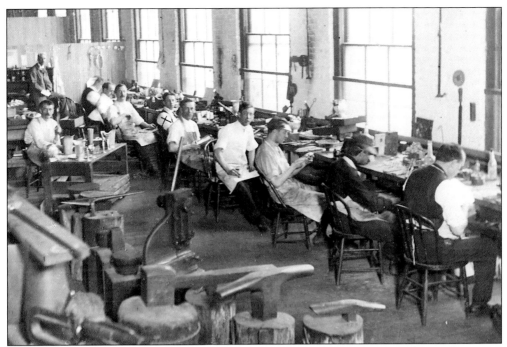

Newburyport Silver Company employees at work in the Church Street plant. These men were still working by hand when this photograph was taken between 1905 and 1915. The firm produced sterling flatware and hollowware. Newburyport Silver was the largest of several silver makers that existed in Keene through the years.

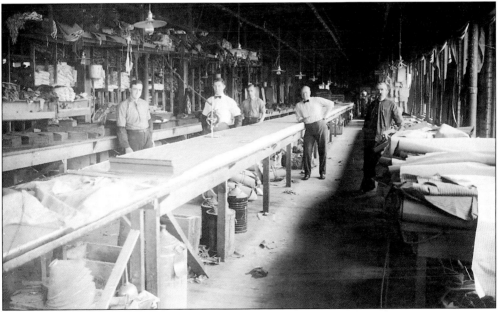

The interior of the Brattleboro Overall Company on Norway Avenue. This clothing manufacturer opened its doors in 1905. The establishment of the Newburyport Silver Company and the Brattleboro Overall Company demonstrates the appeal of Keene to out-of-town firms as an economic and distribution hub, with a skilled labor base.

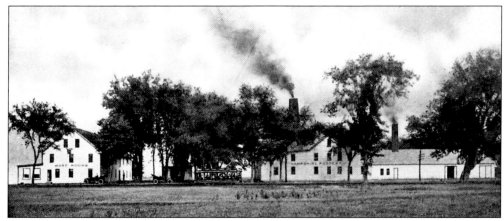

The Hampshire Pottery Company as it appeared shortly before 1916. Exploiting one of Keene's natural resources—fine clays—this company produced its wares for more than half a century, and achieved a national reputation for its art pottery. It was founded by James S. Taft in the early 1870s.

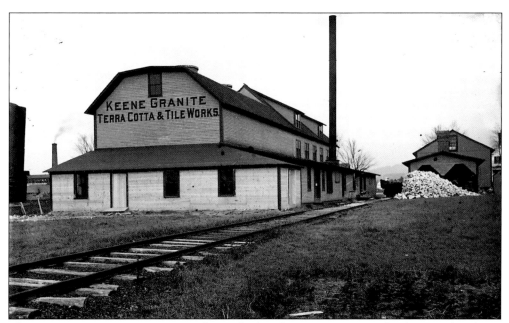

The Keene Granite Terra Cotta & Tile Works found an innovative use for the overabundance of New Hampshire granite. The company molded vases, pitchers, urns, tiles, and building bricks from crushed granite. The Water Street plant operated for three years, from 1891 to 1894.

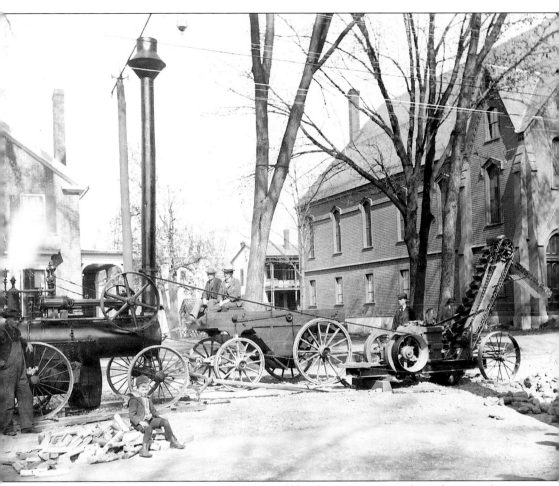

Paving Court Street in the late 1880s. The city itself has been a major employer for more than a century. Building and maintaining streets, water systems, sewers, cemeteries, and other public assets requires considerable manpower. This view reveals the road building technology of the late nineteenth century. A large wood-fired steam engine powers a rock crusher as two supervisors sit on an elaborate dump wagon. Visible at the right is the Second Congregational Church.

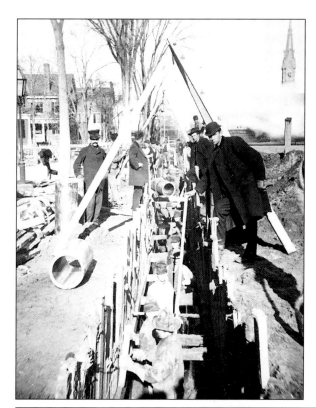

The installation of Keene's first sewer system in November 1882. This was finished thirteen years after the construction of a municipal water system. Superintendent Daniel Sawyer, in the derby hat, inspects the work on Main Street.

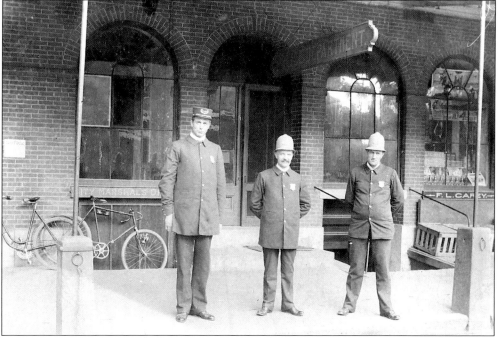

More city employees: Marshall Benjamin Hall and constables William Philbrick and Robert Tolman posed in front of City Hall, c. 1905. Marshall Hall reported ninety-five arrests for the four-month period ending March 1, 1905; eighty-three were for drunkenness.

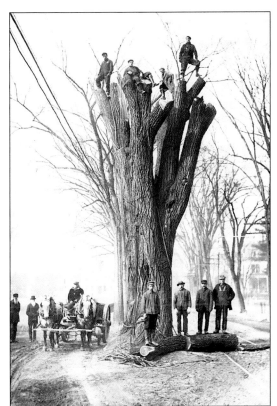

The removal of the Cooke Elm from West Street in March 1914. The tree stood on this location for more than 140 years. As West Street was widened during the nineteenth century, vehicles passed on either side of the tree. The advent of the automobile finally doomed this prominent landmark.

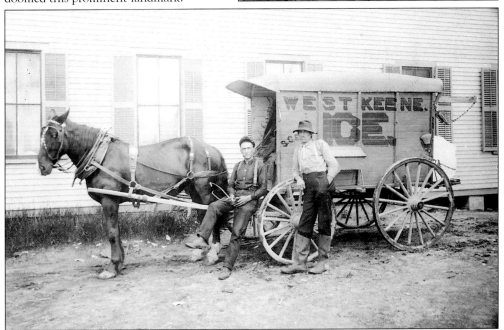

Sidney C. Ellis' West Keene Ice delivery wagon. The ice man was an important merchant in the days before refrigeration. Ellis, who operated West Keene Ice from 1901 to 1908, was one of three ice dealers in the city. Ice was cut in several local ponds for sale to city residents.

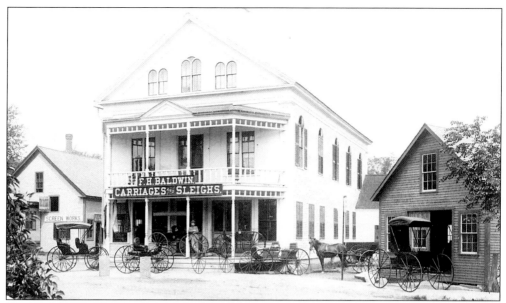

Frank H. Baldwin's carriage and sleigh store on Vernon Street. Baldwin operated his shop in the former Methodist church building for about twenty years, from the 1880s to the early 1900s. He kept pace with the times by adding bicycles to his stock in 1897.

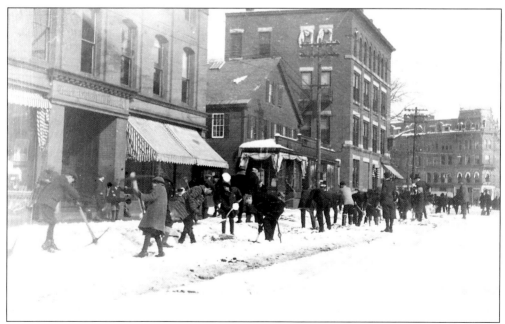

Local boys hired on to clear ice and snow from the trolley tracks on West Street in the early 1900s. This labor intensive chore offered temporary employment and a little spending money to local youth. The YMCA, to the left, stood where the Cheshire County Registry of Deeds is located today.

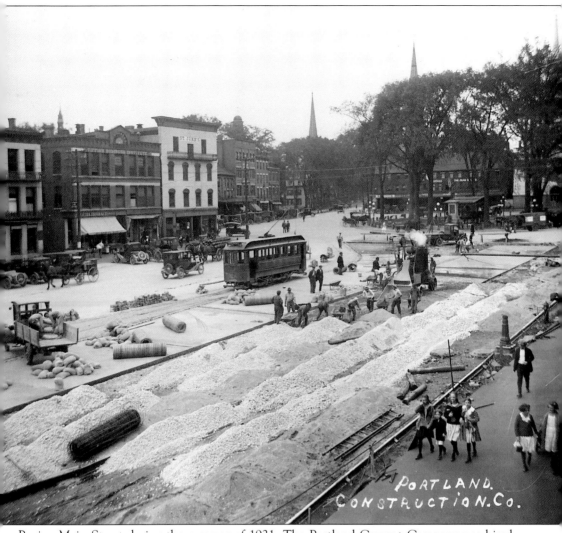

Paving Main Street during the summer of 1921. The Portland Cement Company was hired to perform this major resurfacing project. A smooth road surface was preferable for travel by automobiles with pneumatic tires. Costing nearly $27,000, the project consumed more than 5% of the annual municipal budget.

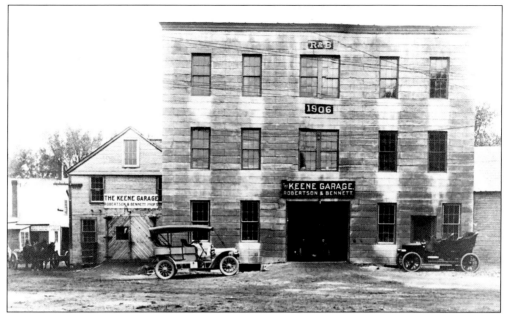

The Keene Garage was one of the city's first automobile dealerships. George Robertson and Frank Bennett began their dealership in 1904, offering Stoddard-Dayton, Stanley, Inter-State, and Ford automobiles. They built this three-story garage behind the Eagle Hotel in 1906.

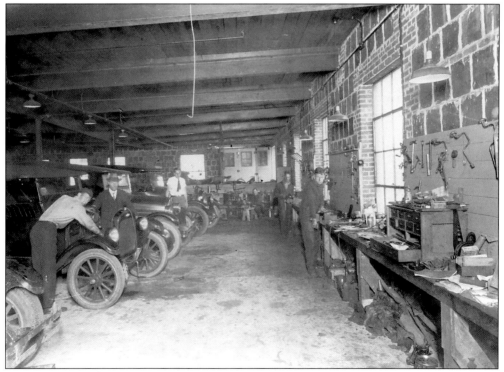

The interior of the Keene Garage, with co-owner Frank J. Bennett wearing the hat. This dealership was the first in New Hampshire to sell dump trucks. The three-story garage building burned on Christmas morning of 1943.

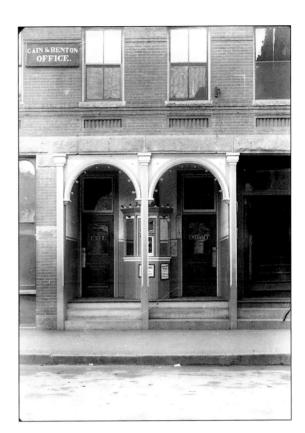

Dreamland Theatre, Roxbury Street, c. 1910. The Dreamland operated in the back wing of the Cheshire House Block, charging 5¢ admission and changing its program daily. Although it operated only a few years, motion pictures were very popular in Keene. The Dreamland was the third theatre opened in the city, and it was soon followed by three additional theatres.

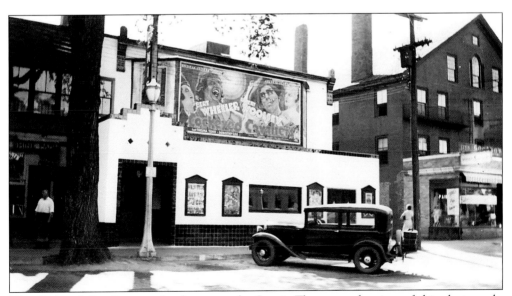

The *Cockeyed Cavaliers* was the feature at the Scenic Theatre at the time of this photograph, taken after reconstruction following a fire in 1927. The Scenic opened on Main Street in 1914 and introduced many of the region's children to the world of movies over the ensuing fifty years.

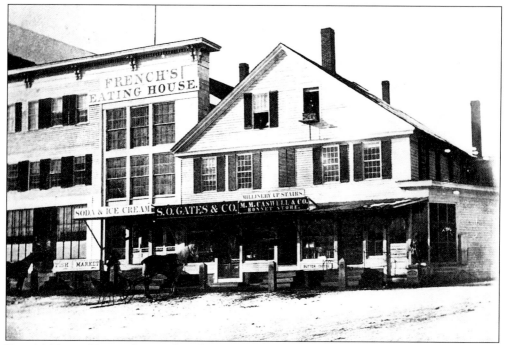

French's Eating House advertised "soda and ice cream" in this pre-1870 view. Restaurants have served travelers from the time of the region's first taverns in the eighteenth century, and an "eating house" has stood at the head of Central Square for most of Keene's history. This block was mostly destroyed by fire in 1880.

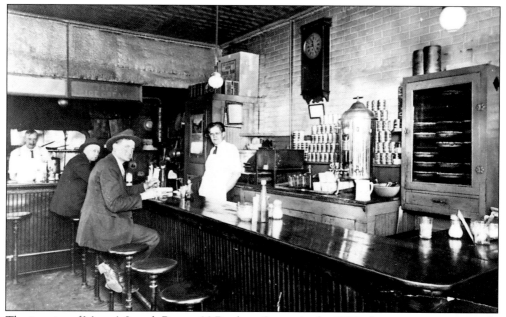

The interior of Morey's Lunch Room, 23 Roxbury Street, in the 1920s. Ice cream was apparently popular at Morey's also, but pie and coffee must have been favorite menu items. Arthur Morey operated his lunch room from 1913 to 1929.

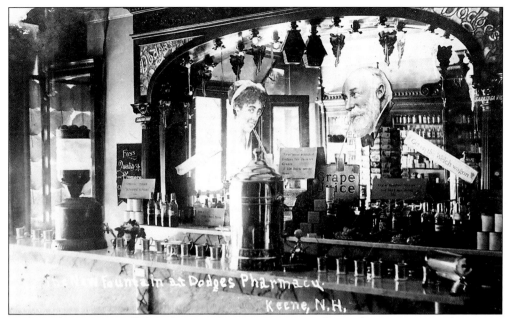

Dodge's Pharmacy installed the latest in fountain equipment during the 1910s. Many pharmacies operated soda fountains. These attracted children, and as a result, their parents, to the stores. While Nahum Dodge sold his pharmacy on Central Square in 1913, later owners retained the "Dodge" name until the store closed in the late 1930s.

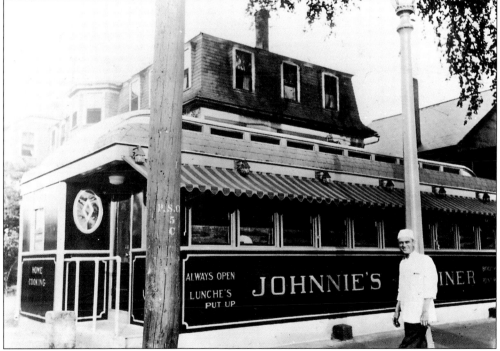

Johnnie's Diner at 92 Main Street in the mid-1930s. The popularity of diners increased during the Depression because of their inexpensive offerings. Proprietor John Judge (shown here), who operated this eatery from 1931 to 1937, advertised "regular 40¢ dinners."

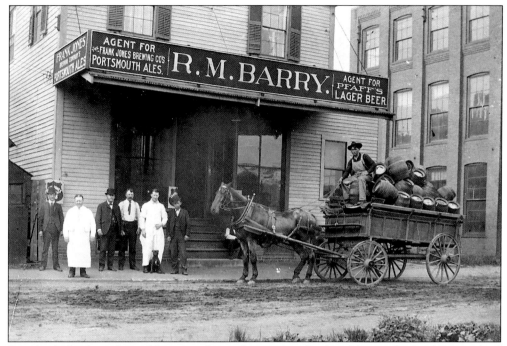

Barry's wholesale and retail liquor and cigar business on Railroad Street. Richard Barry, third from the left, operated a restaurant here before he became a wholesaler to other local stores and restaurants. He was an agent for Frank Jones Ales (of Portsmouth, New Hampshire) when this photograph was taken between 1905 and 1908.

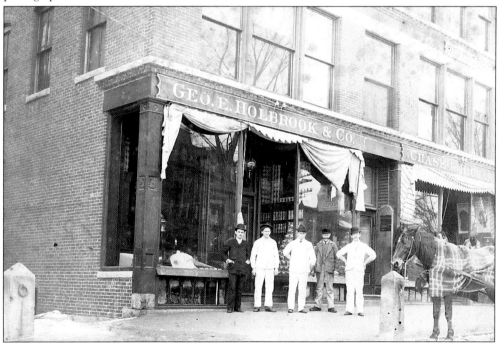

The Geo. E. Holbrook & Co. grocery store and staff. This Main Street store operated for more than sixty years. The business opened in 1871; it last appeared in the city directory in 1934.

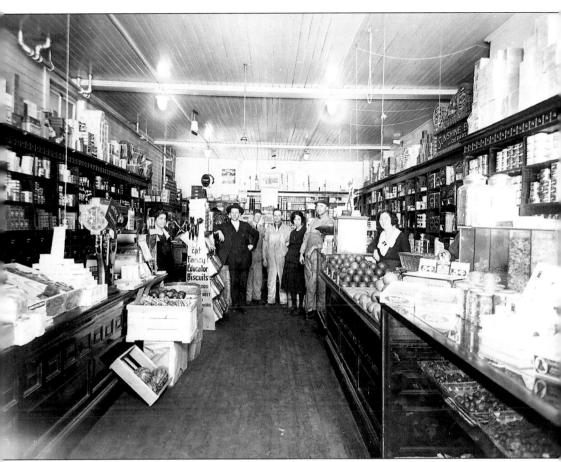

The interior of the Geo. E. Holbrook grocery store in the early 1900s. George E. and George W. Holbrook opened this family business in 1871. Holbrook & Co. was New Hampshire's largest wholesale grocer by 1895. The Main Street retail store, shown here, was separated from the wholesale branch at that time. Holbrook's wholesale company remained in business until 1972.

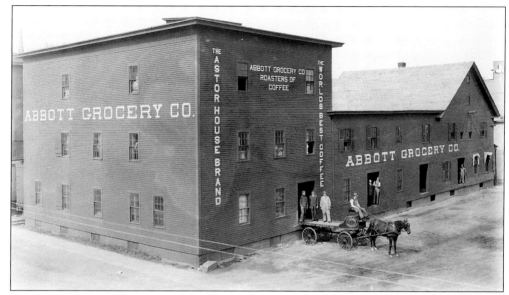

The Railroad Square buildings of the wholesale grocery firm Abbott Grocery Co. It was not a coincidence that this company located adjacent to the rail yards. Abbott and its competitor Holbrook Grocery took full advantage of the city's railroads. They imported groceries by rail and then delivered by wagon to customers many miles into the countryside. Charles Abbott's firm operated from 1890 to 1939.

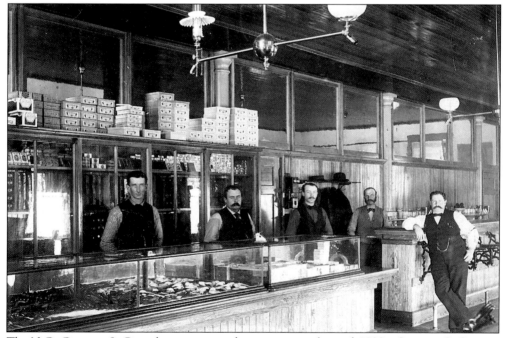

The N.G. Gurnsey & Co. tobacco store and restaurant in the mid-1890s. Gurnsey & Co. was one of Keene's most diverse and long-lived businesses. The company was founded by Norris Gurnsey in 1859. The business eventually grew to three companies that operated restaurants and a bakery, rented rooms, and dealt in tobacco, cigars, crackers, candy, soda, beer, and horse and carriage furnishings. The Gurnsey family retained the company into the 1960s.

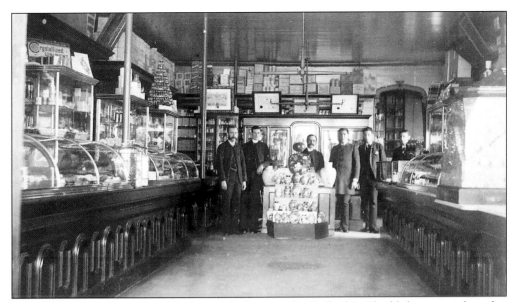

"The Old Corner Drug Store" had recently become the Bullard & Shedd drugstore when this shot was taken, c. 1885. The firm was already forty-five years old by that time. In addition to drugs and medicines, the store offered candy, fruit, cigars, perfume, surgical instruments, and "ventilated trusses." Bullard & Shedd, still located in the same storefront on Central Square, is now one of the oldest drugstores in New Hampshire.

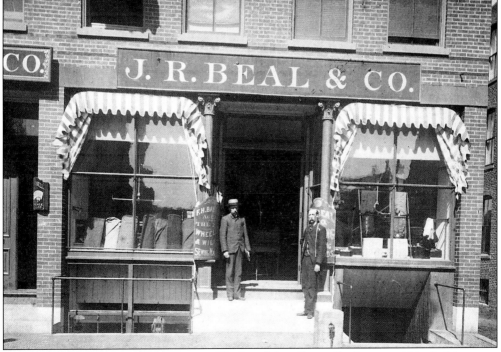

J.R. Beal's Clothing Store in the Lamson Block on Main Street. Beal operated his clothing store and tailor shop from 1860 until his death in 1895. He designed custom uniforms during the Civil War. The company remains in business today as Miller Bros.-Newton.

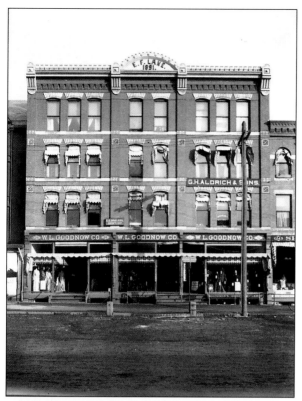

W.L. Goodnow & Co. became a Main Street institution for almost a century following its opening in 1893. The clothing store soon added meat and grocery departments. This view dates from the 1920s, by which time Goodnow's had opened twenty-two department stores throughout New England.

Packaging Wright's Silver Cream at the company's new plant on Dunbar Street in 1940. John Artemus Wright manufactured silver polish using local diatomaceous earth beginning in 1873. J.A. Wright & Co. continues as a leader in the metal polish industry today more than 120 years later, and in its fourth generation of family ownership.

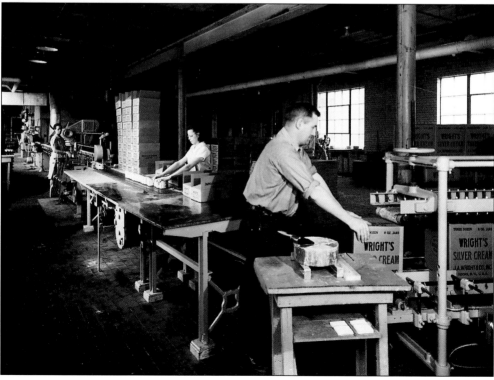

Three

THE FACES OF KEENE: STREET SCENES, BRIDGES, SCENIC VIEWS, AND HOMES

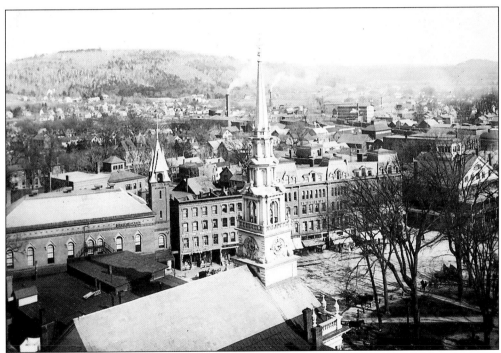

Beech Hill and the eastern side of the city from the Baptist Church steeple in about 1905. The hills which flank downtown Keene have been a deterrent to development, and consequently frame the city with a picturesque horizon line. The hills forced most human activity onto the valley floor, causing residential neighborhoods, such as that on the left, to remain close to Central Square. Notice the last open fields on Beech Hill, reminders of the once cleared landscape that supported agricultural pursuits.

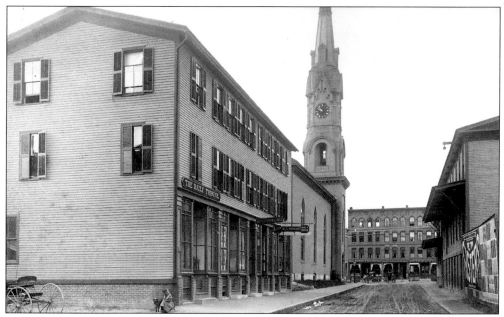

Church Street looking toward Main Street in 1889 or 1890. The Unitarian Church from which the street got its name dominates the center of the photograph. Businesses were filling in the side streets, attracted by lower rents. The *Daily Tribune*, Keene's first daily newspaper, survived for only fifteen months.

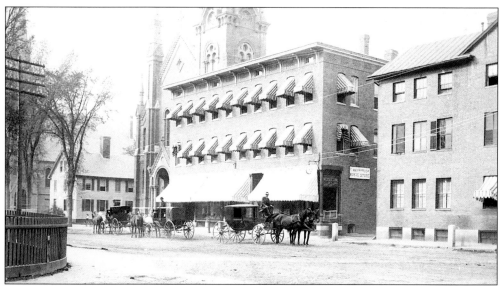

Hacks lined up on Court Street during the 1880s. The Second Congregational Church and Baptist Church stood alongside the imposing Museum Block. This new block housed A.B. Skinner's department store. You could find a little bit of "everything" at Skinner's "Museum," from furs and clocks to fishing tackle and dynamite.

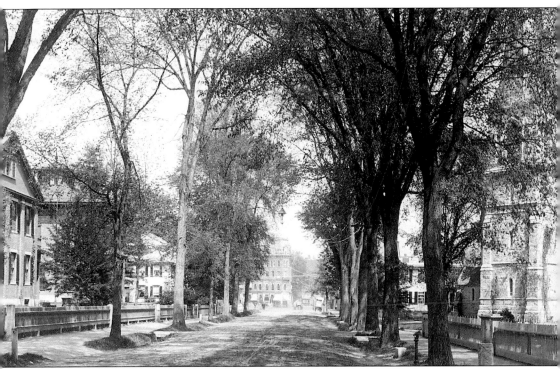

West Street looking toward Central Square. This classic view by long-time Keene photographer J.A. French shows the character of the city in the late 1800s: quiet elm-lined residential streets leading into the Central Square and Main Street business district.

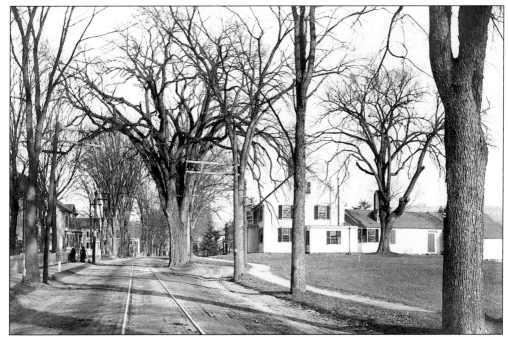

West Street, the Cooke Elm, and the Noah Cooke House during the first decade of the 1900s. The Cooke Elm stood in West Street until 1914; the trolley line survived twelve years longer. The Cooke House, *c.* 1791, survives today, but in another location. It was removed in 1973 to make way for the construction of the Keene Savings Bank (Granite Bank) building.

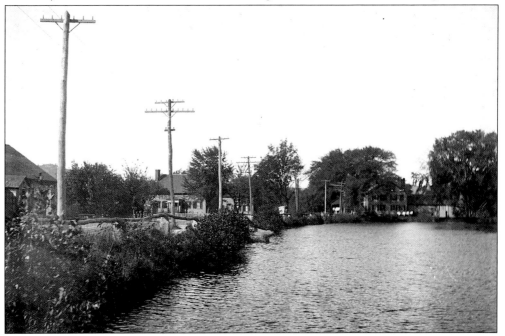

The Faulkner & Colony mill pond bordered West Street in the 1880s. The reservoir powered the machines of the Faulkner & Colony woolen mill for many years. It was a favorite spot for skating until the mid-1900s. The site has been filled and paved for a parking lot.

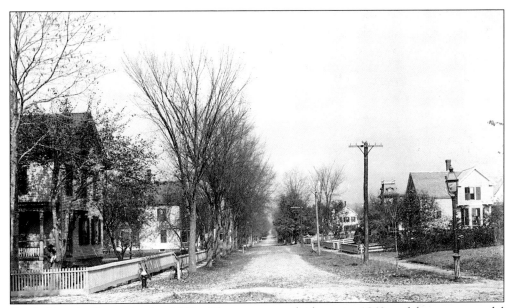

South Lincoln Street in the 1890s. The street was laid out in 1860 and became a model neighborhood of laborers and businessmen alike. The population of Keene doubled between 1850 and 1880 as the city enjoyed an economic boom spurred by industrialization, expansion, and the railroad.

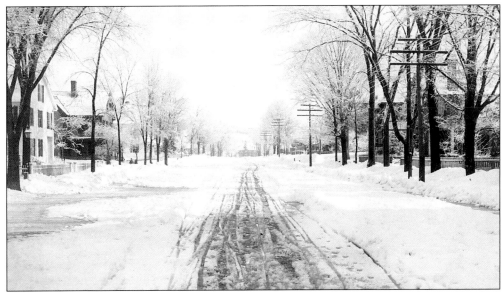

Washington Street on the first day of spring, 1888. Another typically wide street of Keene lay under a blanket of fresh snow. The Cheshire County jail, visible in the distance, was erected in 1884.

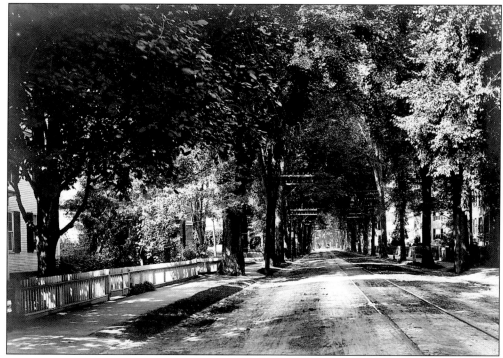

West Street in the early 1900s. The summer foliage on the elms formed a canopy over many Keene streets. This urban forest was lost to the hurricane of 1938 and to the Dutch elm disease.

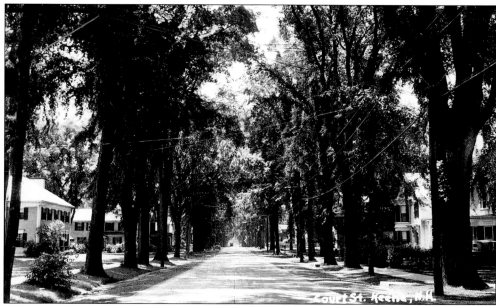

Radiating northwest from Central Square, Court Street in 1938 was paved with concrete. Many of these trees were destroyed by the 1938 hurricane a few months after this photograph was taken.

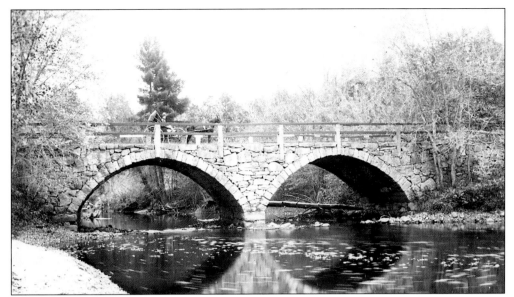

The stone arch bridge over the Ashuelot River. Built in 1840, this was one of many stone arch highway bridges built in the region in the mid-nineteenth century. These structures were built without mortar and were sustained by the keystone at the top of the arch. This bridge still stands on upper Court Street.

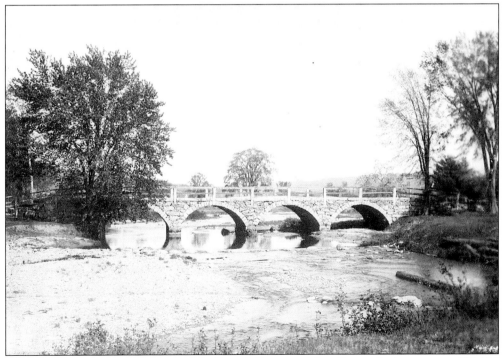

This four-arch stone bridge spanned the Branch River on Main Street. Built at a cost of $2,100 in 1839, this bridge withstood the ravages of nature before being replaced by man in the twentieth century.

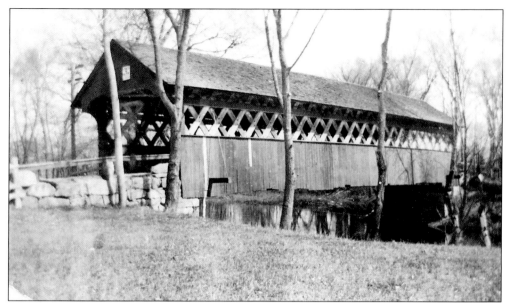

The Winchester Street covered bridge. In the nineteenth century, Keene's watercourses were spanned by as many as seven covered bridges. However, ever-larger trains and autos required stronger structures of steel and concrete to bear the increased loads and traffic. This 1851 wooden structure was removed in 1910.

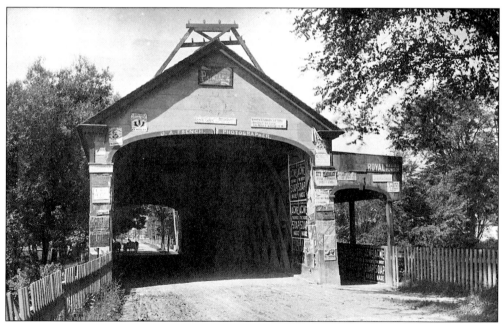

The West Street covered bridge over the Ashuelot River. Covered bridges offered a prime location for advertising posters for the slower traffic that traversed them. This 1830s structure was replaced by an iron bridge in 1900.

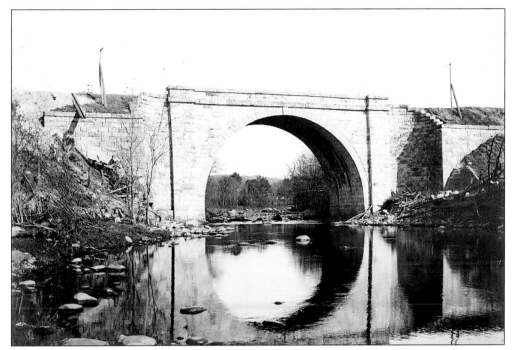

The stone arch railroad bridge at South Keene. This bridge was built in 1847 to carry the trains of the Cheshire Railroad over the Branch River before their final descent into the village. It was one of the highest stone arch bridges in New England, standing 60 feet above the water at the keystone.

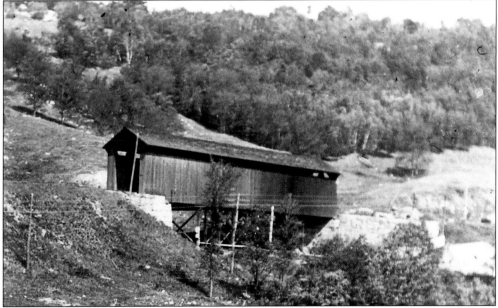

The Manchester and Keene Railroad bridge over Eastern Avenue. This covered bridge carried the trains of the Manchester and Keene line over both the street and the Cheshire Railroad track which crossed the street at the same location. The Manchester and Keene, the city's third railroad, operated from 1871 to 1936.

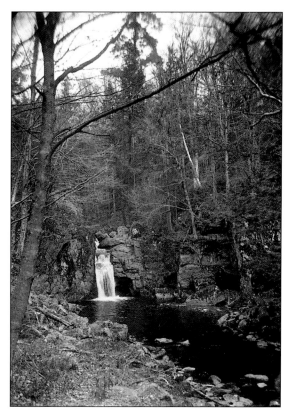

Beaver Brook Falls, only 2 miles from Central Square, was a popular picnic destination. Attractive most days of the year, Beaver Brook has long been a scourge of Keene's east side when melting snow and rainfall render it a freshet.

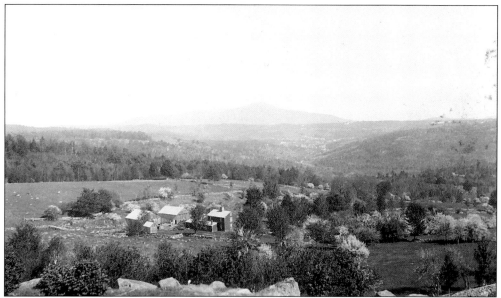

Mt. Monadnock from Beech Hill, c. 1895. This view to the southeast reminds the viewer of the community's agricultural heritage. The active Keene farm in the foreground is surrounded by neat stonewalls, fields, and orchards. The view of villages, fields, and forests in the distance encompasses portions of Marlborough and Dublin and culminates at the peak of Monadnock 9 miles distant in Jaffrey.

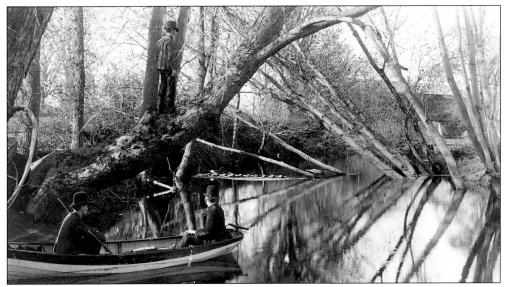

These gents appear to be enjoying a pleasure cruise on the Ashuelot River as it winds through the center of the city. The river was central to the community's economy beginning in the 1730s, supplying power to mills, water for crops and livestock, and transport for people and products. The Winchester Street covered bridge is visible at the right rear of the photograph.

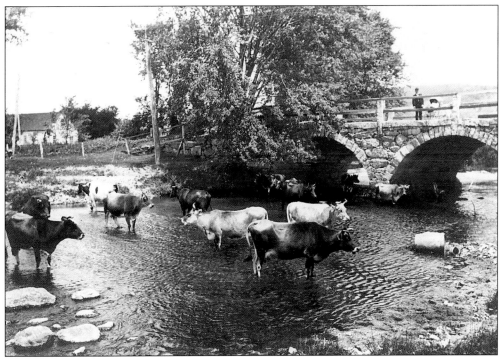

These cattle appear to be cooling themselves in the Branch River. This seemingly "rural" view was actually taken at lower Main Street during the early years of the present century.

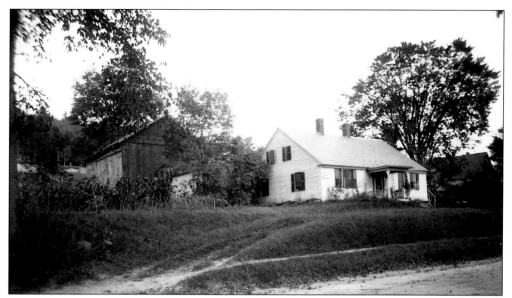

The oldest surviving house in Keene. This Marlboro Street home was built in about 1750 by Seth Heaton, one of the original settlers of the township. His first home had been burned during the Indian raid of 1747 as had been all his neighbors'. Four of Heaton's sons subsequently served in the Revolutionary War.

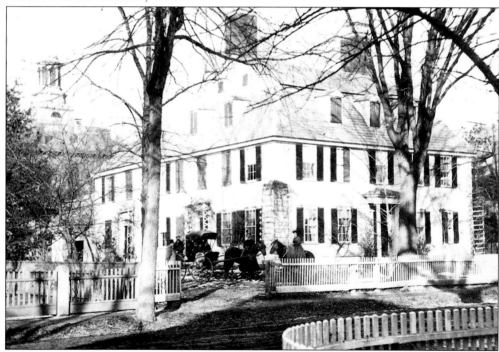

Richardson Tavern, West Street near Central Square. Josiah Richardson built his large foursquare tavern in the early 1770s, one hundred years before this photograph was taken. Prince Edward, the father of Britain's Queen Victoria, is reported to have spent the night of February 4, 1794, at the tavern. The house was removed in 1893 to allow the construction of the YMCA building.

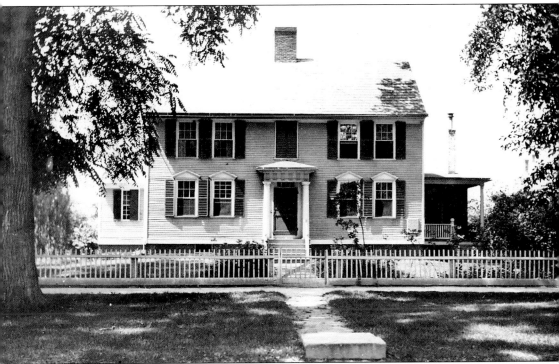

The Wyman Tavern was probably the finest house in town when it was built in 1762. It was operated as a tavern by the Isaac Wyman family for forty years after its construction. The tavern was the site of the first meeting of the trustees of Dartmouth College in 1770. Five years later, on the morning of April 23, 1775, Keene's "minutemen" assembled here at dawn before marching off in response to the Lexington and Concord alarm that heralded the War of Independence from Great Britain. Now listed on the National Register of Historic Places, the tavern is operated as a period house museum by the Historical Society of Cheshire County.

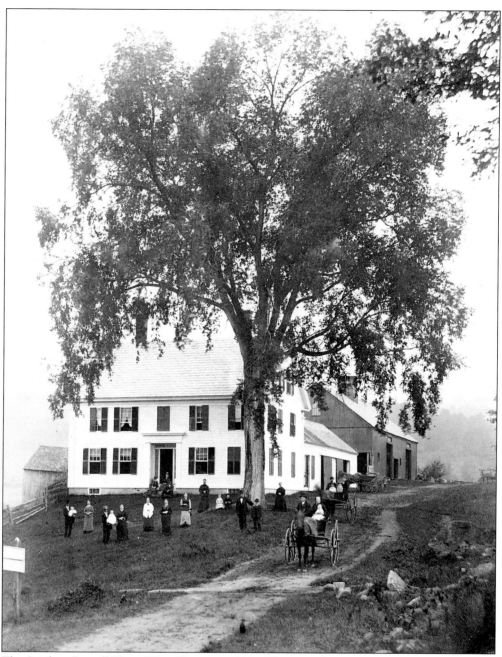

The Stephen Russell Place, West Keene, *c.* 1880s. The Russells clearly took pride in the family farm, as they posed to record for posterity their connection with the house. Many such rural families were photographed during the early decades of the new technology, providing indelible images of proud households standing before their life's work—the old homestead.

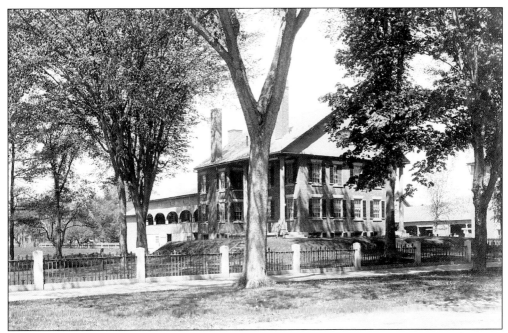

The General James Wilson House, at the corner of Emerald and Main Streets. James Wilson was a prominent local lawyer, state militia leader, and national political figure during the mid-1800s. His mansion was built about 1830. This 1890s view shows his home before the transformations of the twentieth century; the house was razed in 1930 to make way for a gas station.

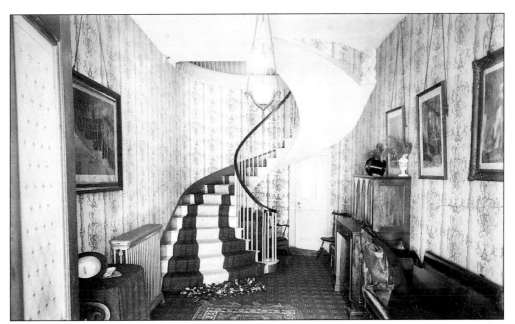

The entry hall of the Elliot Mansion on Main Street. Captain William Wyman, for whom this elegant mansion was built, died just before the house was completed in 1811. This photograph is from the half century of Elliot family occupancy. When James Bixby Elliot passed away, his house was donated to the city in 1892 for use as a community hospital.

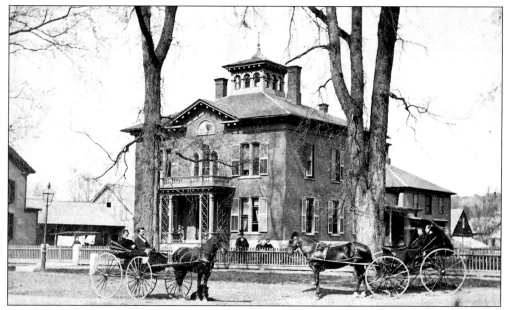

The Ball Mansion during the 1870s. This Italianate home was built for George W. Ball in 1870. Ball was a prominent Keene businessman, operating a brick yard and clothing store. This house served as a private residence until it was acquired in the late 1920s by the Keene Normal School (now Keene State College) for use as the school library. It is now the home of the Historical Society of Cheshire County.

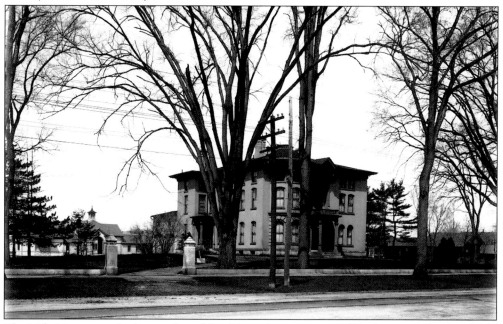

The Hale House was the home of two New Hampshire governors. The house was built in 1860 on the corner of Main and Winchester Streets for Governor Samuel Dinsmoor. It was later the home of Governor Samuel Hale. This photograph was taken in 1909 when the building was presented to the state of New Hampshire by the people of Keene for use by the newly established Keene Normal School.

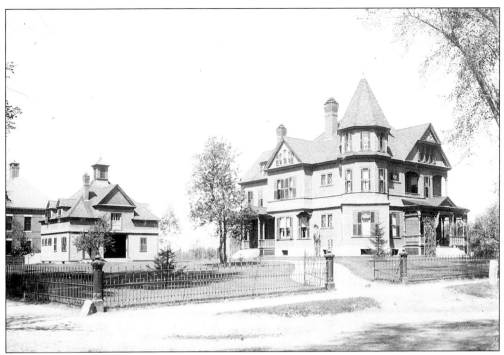

The Joslin House on Court Street in the 1890s. This Queen Anne home had been constructed just a few years earlier for Charles E. Joslin, owner of the Cheshire Chair Company. It was a centerpiece in a neighborhood rapidly becoming the preferred address of Keene's industrial and professional leaders.

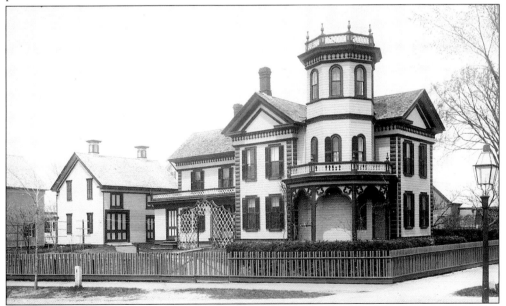

The Stone Homestead, c. 1890. Carpenter and building contractor Edwin Clark built his Washington Street home in 1869–70. He sold the home for $4,600 in 1885 to William and Mary Hall, proprietors of the Ladies Exchange dry goods store. The house was acquired by Charles Stone, co-founder of the hardware firm Knowlton & Stone, at the turn of the century.

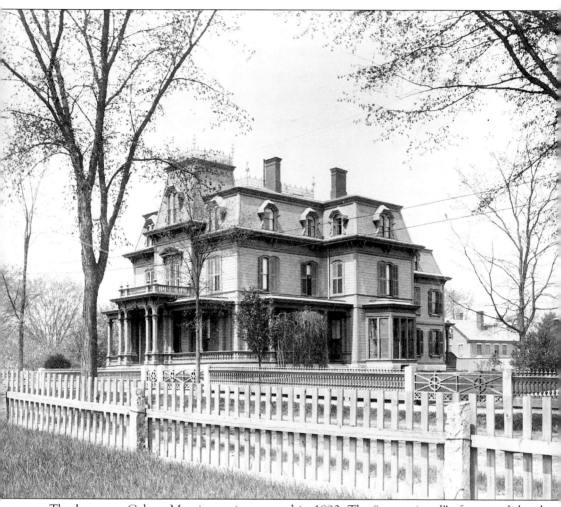

The Laurence Colony Mansion as it appeared in 1890. The "crown jewel" of a consolidated industrial neighborhood, this French Second Empire home contained in excess of twenty rooms. Built for Alfred T. Colony, the house stood diagonally across West Street from the Faulkner & Colony woolen mill, and directly across from partner Charles S. Faulkner's residence. Mill hands lived in neighboring houses and tenements, such as the one visible at the rear of the mansion. Fast food restaurants now occupy the site of this stately manse, long recognized as one of Keene's historical and architectural landmarks. It was razed in 1968.

Four

TRANSPORTATION

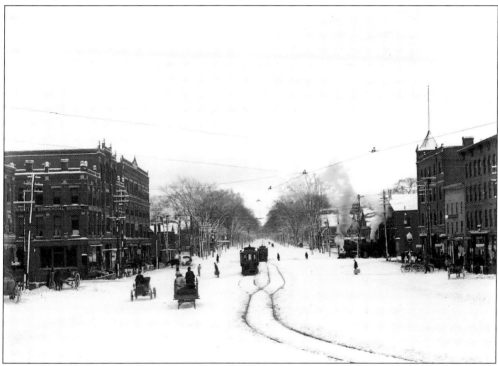

Traveling through the snow on Main Street, c. 1907. This view illustrates the revolution in transportation which occurred at the beginning of the twentieth century. Horses, wagons, and sleighs are visible along Main Street. As a train pulls out of the station, two trolleys pass on the street, and an automobile owner braves the snowy roads. The growth of Keene has always been closely linked to developments in transportation. The Connecticut and Ashuelot Rivers offered natural travel routes into the wilderness in the mid-1700s. Several turnpikes and stage routes were developed through the village by the early 1800s. The arrival of the railroad in 1848 brought a bona fide prosperity. Finally, the introduction of automobiles at the beginning of the 1900s had a monumental impact on life in the region. Autos enabled people from the surrounding countryside to travel to Keene for trade, banking, and work, and enticed tourists to visit the "Currier and Ives Corner" of New Hampshire.

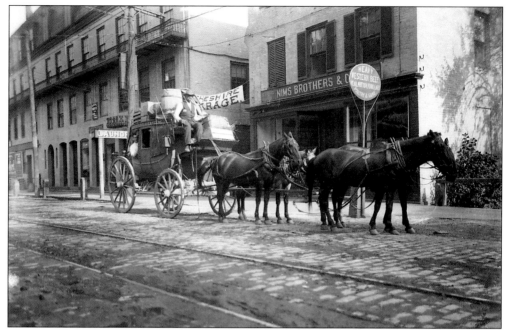

A Spofford Lake & Keene stage on West Street. The railroad allowed city dwellers to escape the summer heat to the cool and refreshing countryside. Once visitors reached Keene, stagecoaches shuttled them on to the mountains or lakes. This stage line carried visitors to the summer hotels at Spofford Lake well into the twentieth century.

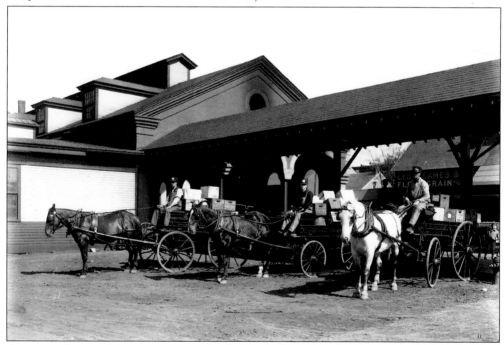

American Express delivery wagons at the depot in May 1908. As the name implies, American Express offered fast and direct conveyance of rail-borne freight to and from local businesses and the depot.

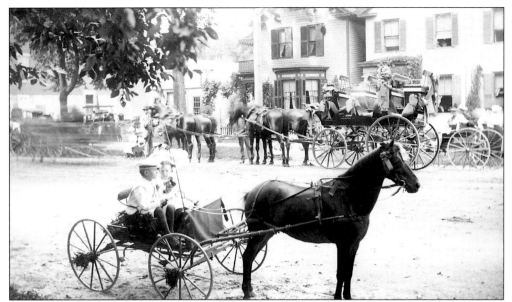

The Cheshire County Grange Fair coaching parade, September 7, 1898. The grange fair coaching parade was an annual event featuring wagons, floats, bicycles, and a wide variety of transportation formats. This young pair waited at the parade staging point in their miniature carriage, perhaps made by Keene's J&F French carriage and sleigh manufacturing company.

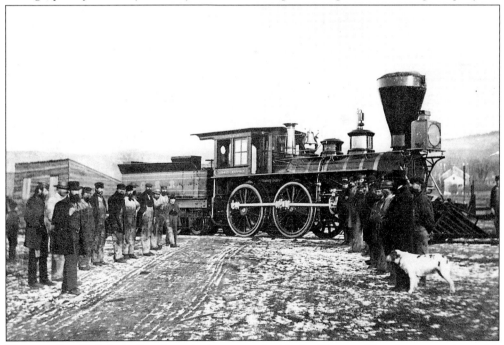

The proud staff of the railroad repair shops posed with the Thomas Thatcher on a winter day in 1863. This important locomotive had just been rebuilt and renamed. Formerly known as the Monadnock, it had been one of the first two locomotives to roll into Keene when the Cheshire Railroad opened in May 1848. The construction of the engine had been completed just one week earlier at a cost of $8,000.

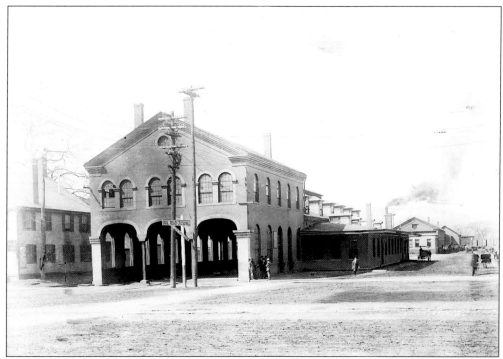

The former depot on Main Street. This state-of-the-art station was constructed for the Cheshire Railroad in 1848, but larger and more powerful locomotives rendered it obsolete. It was a sad day in Keene when the Boston & Maine, which took over the line in 1900, replaced the old depot with a new one in 1910.

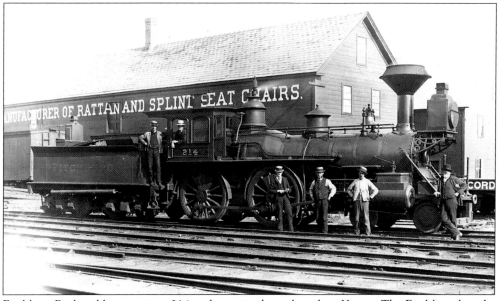

Fitchburg Railroad locomotive #214 and crew in the rail yards at Keene. The Fitchburg bought out the Cheshire Railroad in 1890, and was in turn taken over by the Boston & Maine in 1900. The Fitchburg began the practice of numbering rather than naming locomotives. What had been the "Fitzwilliam" became the impersonal "#214."

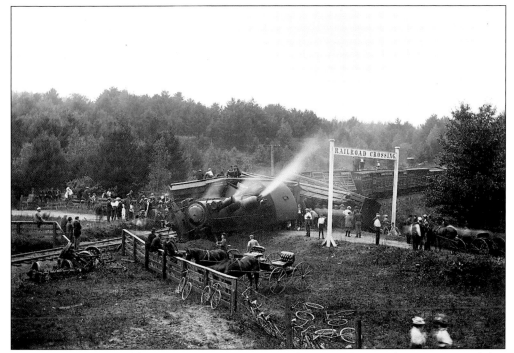

The wreck of the Fitchburg #246 at West Keene, July 17, 1897. Two locomotives and five freight cars of this hog train derailed at West Keene, resulting in the death of engineer Milan Curtis, and many hogs. Such wrecks drew large crowds of curious bystanders, including at least nineteen who came by bicycle to view this derailment.

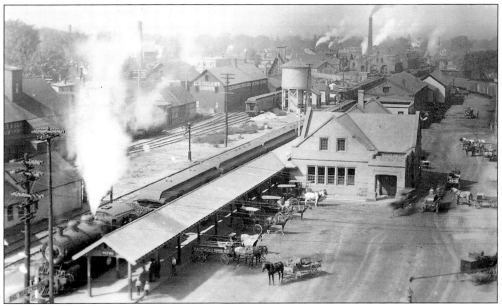

The Boston & Maine Railroad station, *c.* 1912. The bustling activity at Railroad Square shows the importance of the railroad in Keene. Factories, warehouses, railroad buildings, trains, and wagons are visible into the distance. A six-coach southbound passenger train has just pulled into the station.

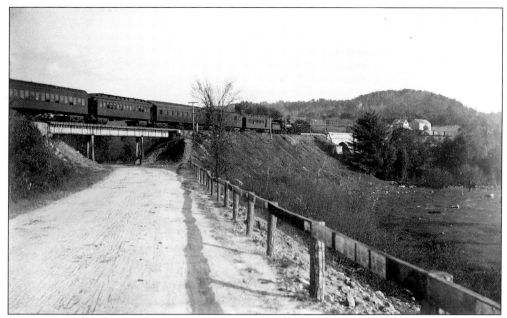

A southbound passenger train crossing the overpass and stone arch bridge at South Keene, c. 1890. The original 1848 rail line that wound through Cheshire County and then on to Boston served freight trains until 1982. Passenger service ended in 1958, succumbing to competition from the automobile and the interstate highway system.

The Boston & Maine Railroad station, Railroad Square, 1958. On the evening of May 31, 1958, the final passenger train left Keene for Bellows Falls, ending 110 years of rail passenger service in Keene. This 1910 station was torn down shortly afterwards.

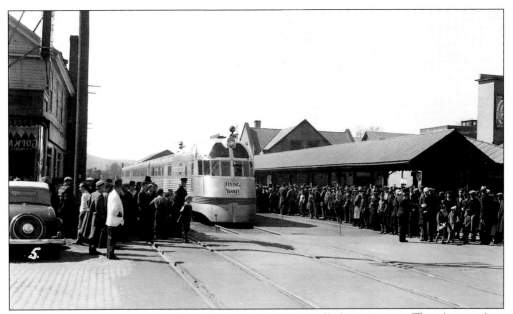

Large crowds greeted the streamliner Flying Yankee as it pulled into Keene. The ultra modern Flying Yankee was the first streamliner in the country, first serving Boston and Bangor in 1935. The streamliner was transferred in 1944 to the Keene-Boston run and renamed the Cheshire.

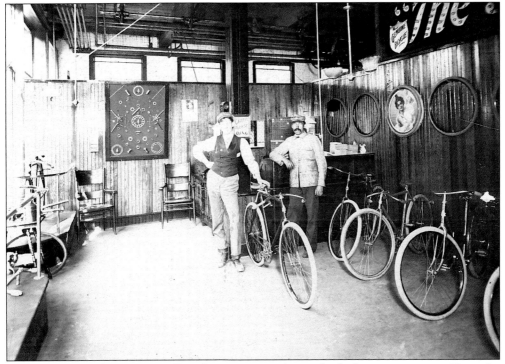

A Keene bicycle shop, c. 1897. Bicycles were a popular method of transportation in Keene by the late 1800s. Bicycle clubs, public outings, and organized races fueled the bicycle rage. The Trinity Cycle Manufacturing Company opened on Church Street in 1897. The firm produced up to sixty bicycles per day, but still could not keep up with orders from across the country.

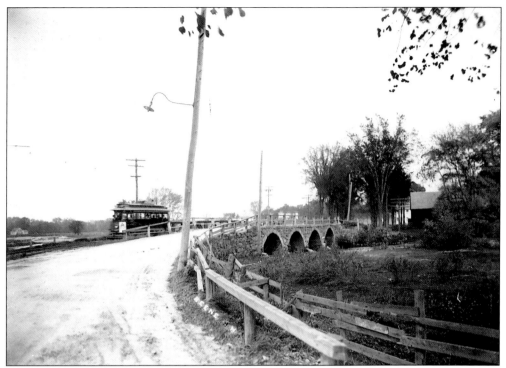

A Keene Electric Railway trolley passing the stone arch bridge on lower Main Street, c. 1905. The trolley system opened in 1900 and operated more than 8 miles of track in Keene, Marlborough, and Swanzey. Despite marginal profitability, the trolley survived for twenty-six years before the company replaced it with buses.

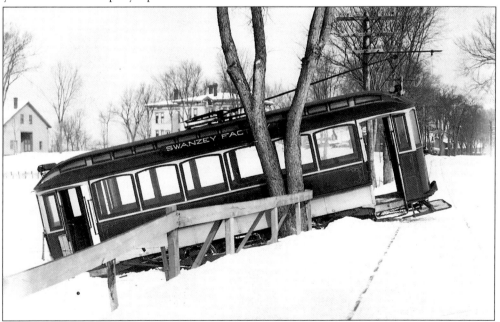

The trolley on the Swanzey Factory run slid off the snowy rails on lower Main Street in 1910. New England winters posed the same challenges to rail vehicles that they do to automobiles.

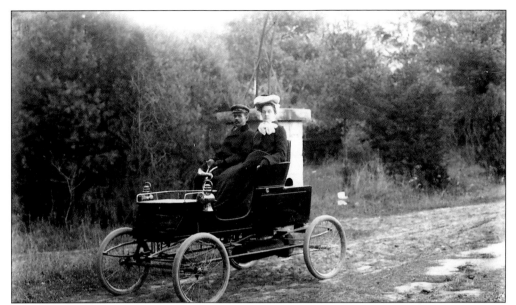

Charles and Lena Aldrich in their Stanley Steamer at the entrance to Wheelock Park. Locally owned autos appeared on the streets of Keene in the late 1890s and early 1900s. Automobiles were often regarded with suspicion in the early years, but they soon dominated roads in the region.

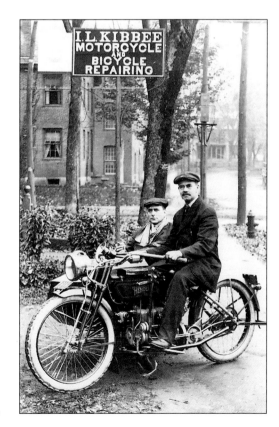

A shiny Henderson motorcycle with sidecar and two passengers on Mechanic Street. Irving L. Kibbee opened his motorcycle and bicycle repair shop in 1915. His son "Red" Kibbee attained considerable local fame as a baseball player.

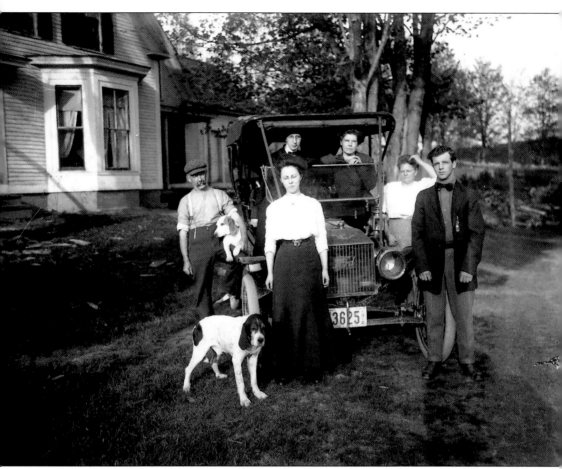

The Whitehouse family posed with their Model T Ford in the spring of 1912. The importance and prestige of the auto is evidenced by countless photographs of Americans who now posed with their beloved automobiles, as their parents and grandparents had posed before their homesteads. This view was taken at the Fred Whitehouse farm on Hurricane Road.

Five

PUBLIC PLACES AND PUBLIC PEOPLE

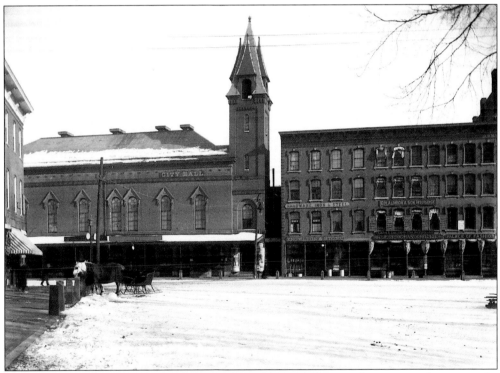

City Hall, erected in 1848, was an impressive addition befitting of a growing shire town. In Keene, as elsewhere, citizens have constructed significant structures to house their governmental, religious, and other public activities. Such structures capture in bricks and mortar the values and pride of the community. Monuments have long been popular subjects for photographers, as have those people who have gained fame through their public achievements. Keene's City Hall was extensively modernized in the 1950s, resulting in the removal of the tower and top floor of the building.

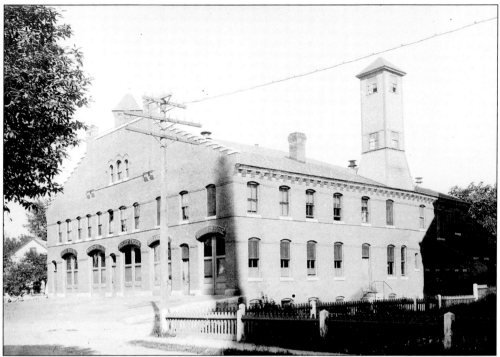

The Keene Fire Station on Vernon Street was erected in 1885 to house the city's three fire companies. The building was enlarged in 1892 to the design shown above. The same building, further enlarged and modernized, still houses the city's fire department today.

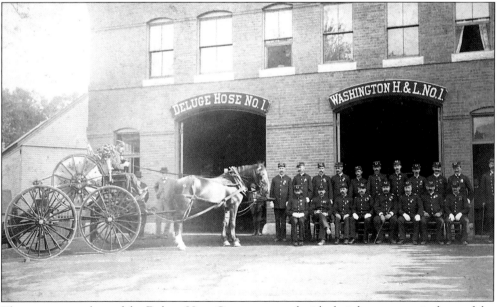

The twenty members of the Deluge Hose Company posed with their hose wagon in front of the fire station, c. 1890. The city's two hose companies and one hook and ladder company had a total of sixty-five members.

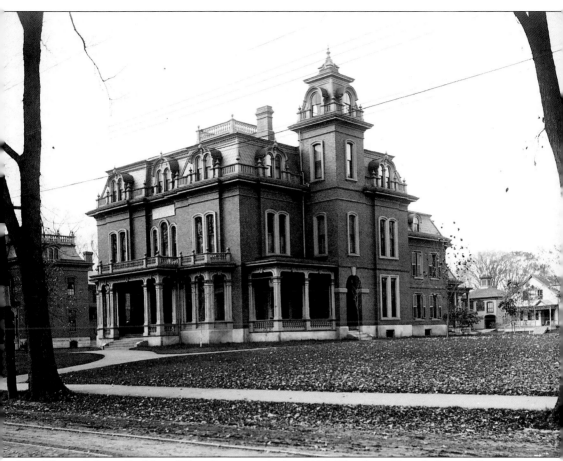

The Thayer Library Building, West Street, soon after 1900. This large French Second Empire structure was built *c.* 1870 as the home of Henry and Hannah Colony. Henry was treasurer and business manager of the Cheshire Mills textile manufactory at Harrisville. The home was given to the city by Edward Thayer in 1898 for use as a public library. With renovations and additions it still serves that purpose today.

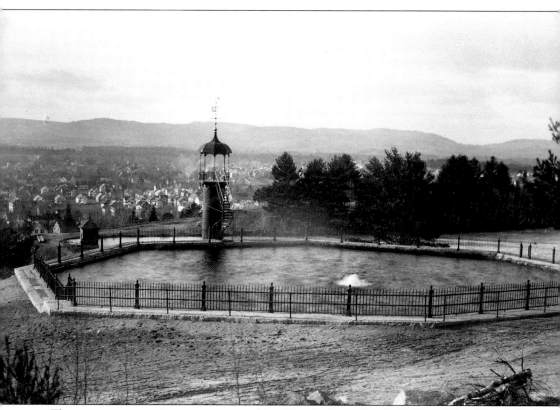

The octagon reservoir was constructed in City Park on Beech Hill in 1886. This hillside addition to the city's water system became a popular spot for picnics and for viewing the city below. During the Depression the reservoir was removed and the "octagon" transformed into an outdoor amphitheater by WPA crews.

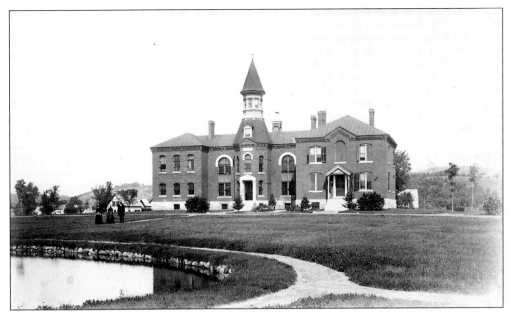

A stroll on the grounds of the Cheshire County jail in the mid-1890s. The Washington Street facility was constructed in 1885 at a cost of about $25,000. In 1925 the city acquired the four-acre parcel of land from the county and created Fuller Park.

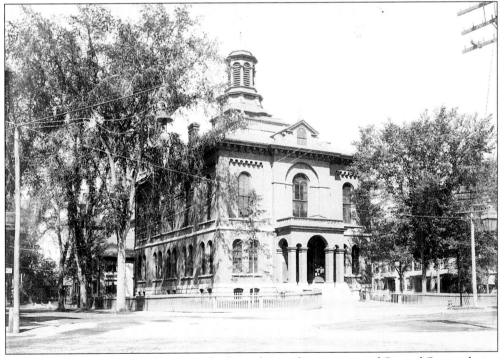

The Cheshire County Courthouse was built on the northwest corner of Central Square during 1858. The Italianate-style structure was one of two New Hampshire buildings designed by prominent Boston architect Gridley J.F. Bryant. It has remained a downtown landmark for almost 140 years and is now listed on the National Register of Historic Places.

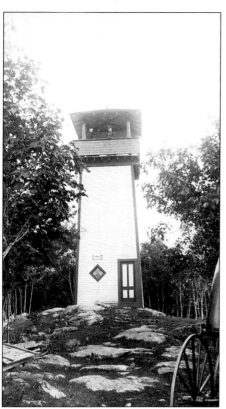

The Horatian Tower was constructed atop Beech Hill in 1890. It offered spectacular views of the surrounding countryside and the city on the valley floor 600 feet below. Horace Goodnow, owner of the 35-foot tower and surrounding park of 300 acres, charged 15¢ for admission to the observation tower. He also encouraged visitors to purchase "unequalled building sites" in the park.

The YMCA building on West Street also housed Chase's Cafe and Gilmore's Bazaar when this photograph was taken, c. 1895. This new "Y" building was erected at a cost of $22,000 in 1893. It served the organization until a new building was dedicated in 1959.

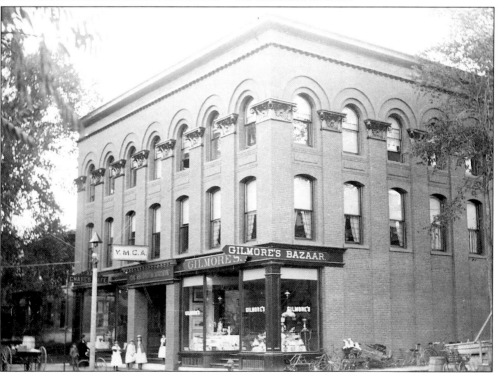

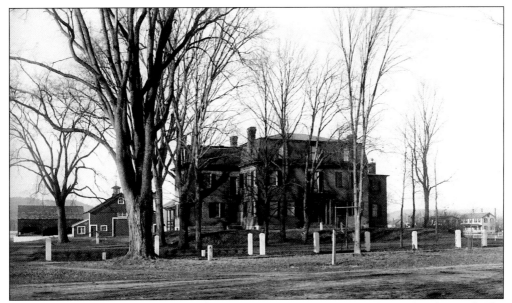

The Elliot Mansion on Main Street soon after its donation to the city for use as a hospital. The mansion was home to the James Bixby Elliot family for almost fifty years before the gift by John Henry Elliot in 1892. This was Keene's first community hospital and served that purpose for eighty years, until a modern facility replaced it in the 1970s.

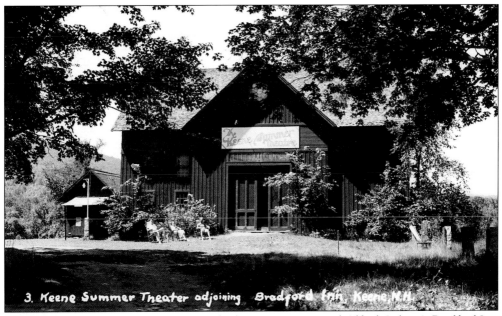

The Keene Summer Theatre opened in the barn at Beatrice and Alfred Colony's Bradford Inn in 1935. The Colony's were long associated with the Theatre as directors and performers. The Theatre suspended operations during World War II, but revived in 1946 and continued into the late 1950s. It was one of many undertakings that helped make Keene a cultural center of the region.

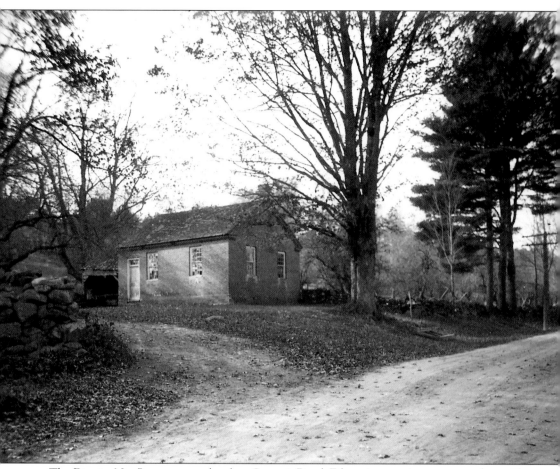

The District No. 7 one-room school on Summit Road. Education was important to the residents of Keene from the earliest settlement. The first record of public support for education dates from 1764, and the first known schoolhouse appeared on Main Street by 1775. The brick No. 7 school, built c. 1839, continued as a school until the late 1890s. The building survives as a sugar house.

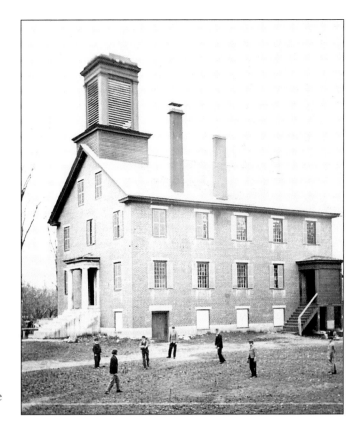

These boys gathered for a ball game in the yard of the Keene Academy, *c.* 1870. The building, built in 1837 for use as a private academy, became a public high school when the Keene School district leased it in 1853. A new high school replaced the academy building in 1875.

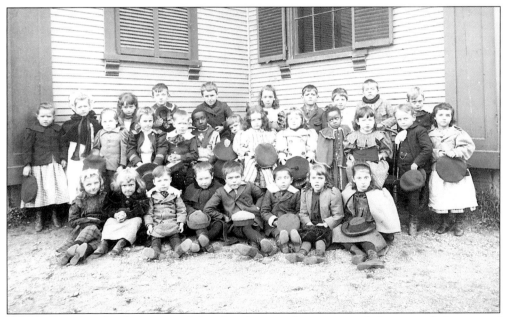

A Keene grade school class posed for the photographer on a cool day around the turn of the century. The students remained still for only a few moments, but their wonderful facial expressions have been frozen on film for all time.

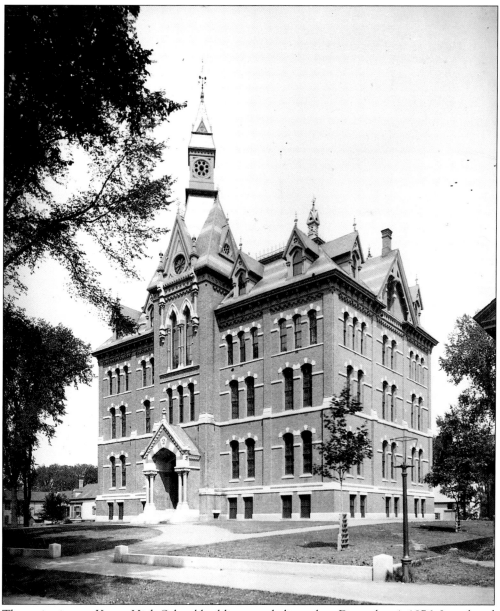

The majestic new Keene High School building was dedicated on December 4, 1876. It replaced the old Keene Academy building on the same Winter Street lot. The building served as the city high school and then as the junior high school until 1953. The school was demolished in 1956 and the land converted into a parking lot.

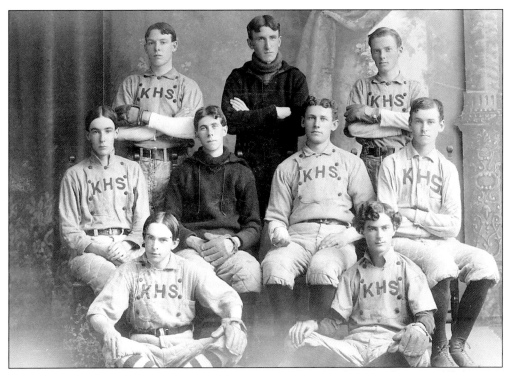

The Keene High School baseball team of 1899. There were only nine players to fill the nine positions on the team. However, there were fewer than one hundred male students in the entire school and only seventeen in the graduating class of 1899.

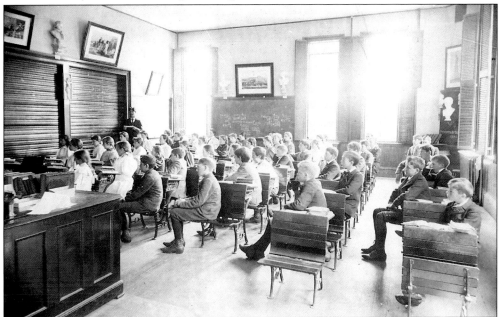

The senior class of the First Grammar School in mid-June 1896. Although the students appear ready to bolt for the door on the last day of class, they were actually engaged in a mental arithmetic class, i.e., solving math problems without using paper.

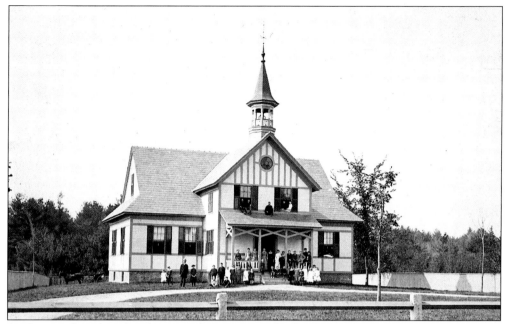

Students and teachers lined up outside Symonds School. This modern school building, erected in 1881, gave way to a larger Symonds School in 1928. The old building still stands on Park Avenue, and is now housing apartments.

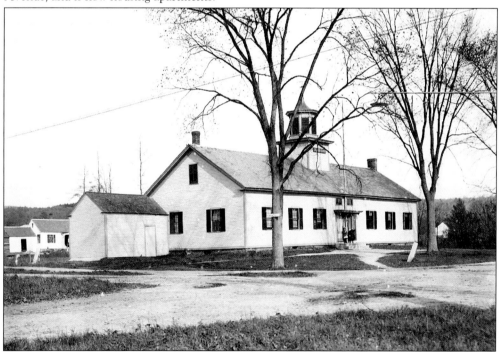

The Fuller School, at the corner of Elm and Spruce Streets. This neat two-room school was typical of the size of the city's schools as the population increased in the late 1800s. This building housed students for at least sixty years before it was superseded by the new Fuller School in 1936.

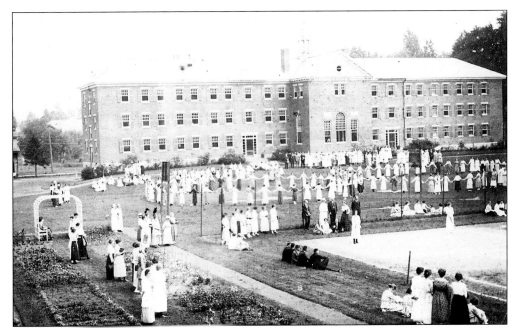

A gathering of students on the grounds of the Keene Normal School in 1920. The teacher's school had grown considerably, in facilities and number of students, from the time it was founded in 1909. Fiske Hall was completed in 1915; it served as a dormitory and dining room. The school became Keene Teachers College in 1939, then Keene State College in 1963.

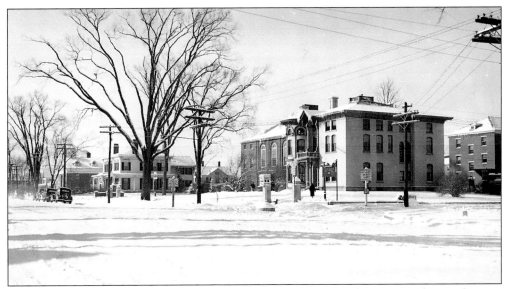

The Keene Normal School from Main Street during the winter of 1938–39. The two historic buildings that comprised the original campus (Bond and Hale Houses) had been joined by three large new brick structures: Spaulding Gymnasium, the Parker classroom building, and Fiske dormitory. The school officially became a college the following spring.

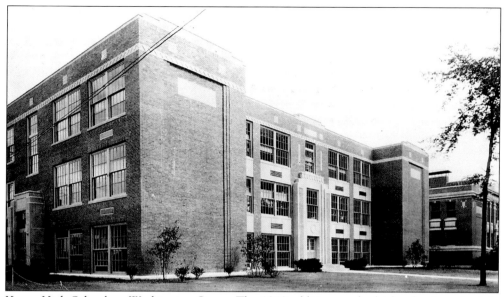

Keene High School on Washington Street. The 1940 addition to the high school, to the left, effectively doubled the size of the school. However, the addition cost twice as much as the original 1912 structure. The building now serves as the Keene Middle School.

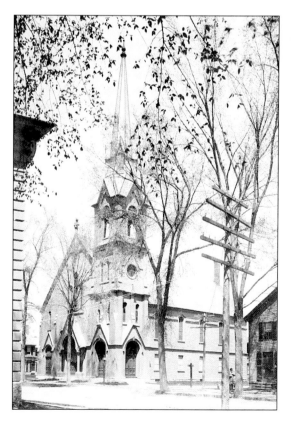

The Second Orthodox Congregational Church on Court Street. This impressive edifice was built in 1868–69 by 122 former members of the congregation of the First Congregational Church. The secession continued in this building for ninety-five years, when a reunification took place with the First Church. The building was demolished in 1965.

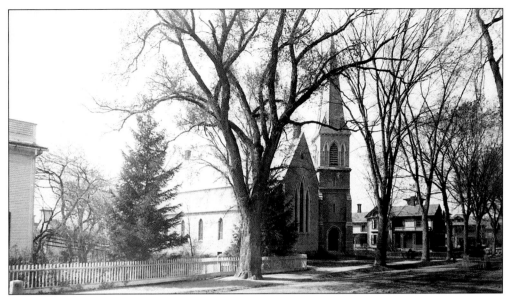

The St. James Episcopal Church on West Street in the late 1890s. Built during the Civil War, the church held its first service in August 1864. The Episcopal parish had been officially organized in Keene in May 1859 following more than half a century of local services performed by visiting clergymen.

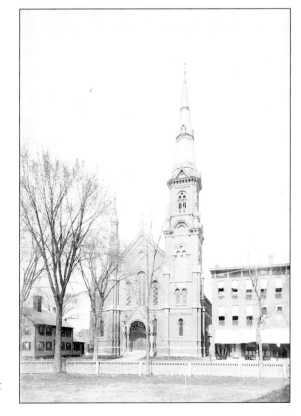

The Court Street Baptist Church, c. 1900. This was the third Baptist church in the community; it was constructed in 1874. The building was made of Keene brick and the steeple towered 167 feet above the street. This building was removed in 1968 following construction of a new Baptist church on Maple Avenue.

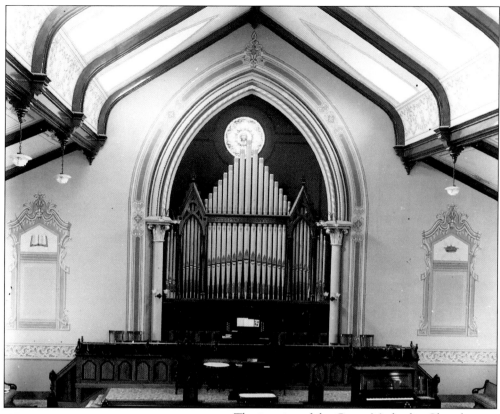

The interior of the Grace Methodist Church, *c.* 1907. This impressive 1869 structure is the last survivor of the three Court Street Churches (Methodist, Baptist, Second Congregational) which stood within a few yards of each other for ninety years. These three towering structures, along with the United Church of Christ around the corner on Central Square, exemplified the powerful religious beliefs of nineteenth-century New Englanders.

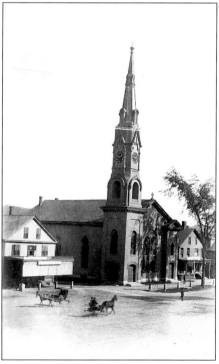

The Unitarian Church, at the corner of Main and Church Streets. A simple 1829 church building was extensively altered to this more elaborate style in the 1860s. The building, gone now for more than a century, is what gave Church Street its name.

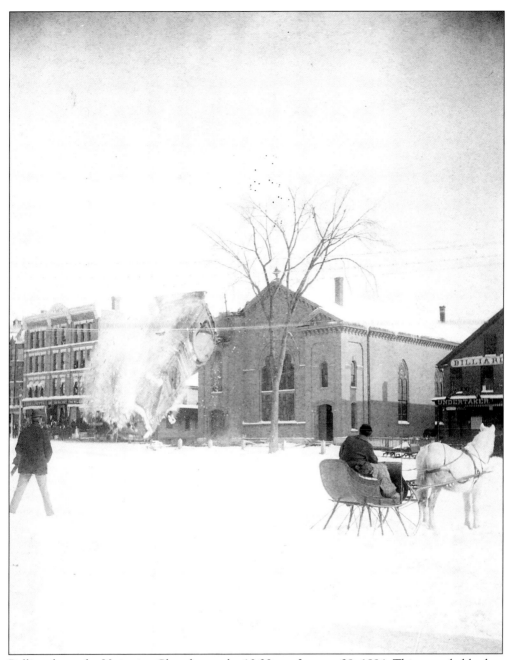

Pulling down the Unitarian Church steeple, 10:32 am, January 29, 1894. This remarkable shot chronicled the demise of this longtime Main Street landmark. Its replacement, the Unitarian Church on Washington Street, was dedicated in January 1895.

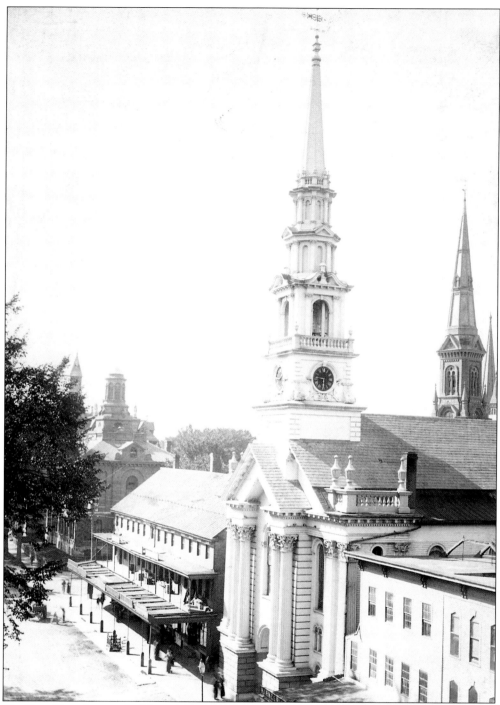

The First Church, now the United Church of Christ, at the head of Central Square. The church has been moved, turned, altered, and raised since it was built as the town meetinghouse more than two hundred years ago. It stands today as the centerpiece and most prominent structure in the downtown. The white church at the head of the Square has become a symbol of the city and its eighteenth-century New England heritage.

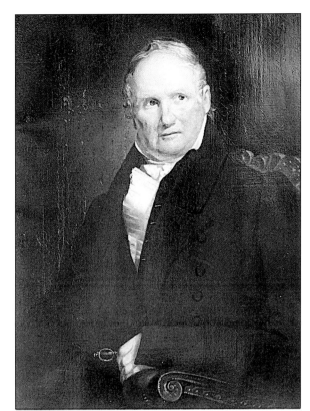

"The Elder Governor Dinsmoor." Samuel Dinsmoor enjoyed active and distinguished public and private careers as an attorney, bank president, postmaster, militia commander, and congressman. He also served the state as governor for three consecutive terms beginning in 1831. His son Samuel Jr. ("the younger governor Dinsmoor") served as New Hampshire's chief executive from 1849 to 1852.

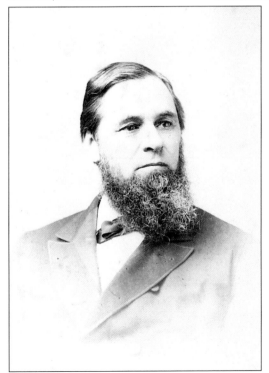

Samuel W. Hale, governor of New Hampshire, 1883–84. Hale was a prominent businessman—he was a bank director, a railroad president, and owner of the South Keene Chair Company and the Ashuelot Furniture Company. His chair company employed approximately six hundred people at the time of his gubernatorial election in 1883.

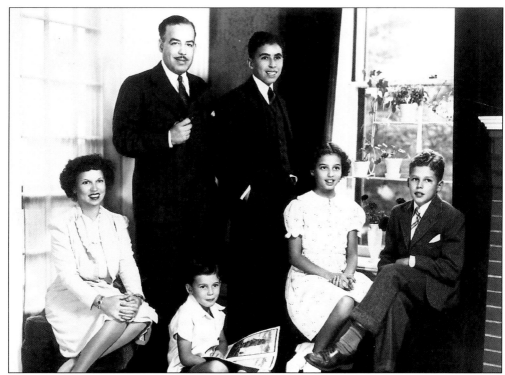

The Dr. Albert Johnston family in the 1940s. From left to right are Thyra, Albert, Albert Jr., Anne, and Donald, with Paul sitting on the floor. This Keene family was the subject of the 1947 book *Lost Boundaries* and the hit 1949 movie of the same name. *Lost Boundaries* was based on their experiences as a black family passing for white for twenty years in New Hampshire.

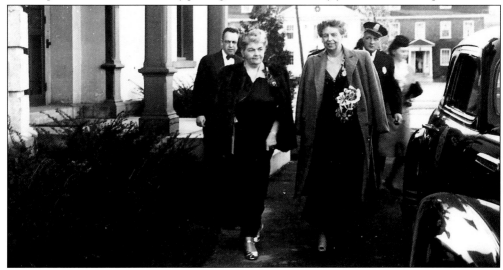

First Lady Eleanor Roosevelt (right) visited the city in April 1945. She was the guest of Lucy Dickinson (left) of Keene, national president of the 2.5 million member General Federation of Women's Clubs. Mrs. Roosevelt spoke on "Education in the Post War World" at the Keene Community Forum. Her husband, President Franklin D. Roosevelt, died only two days after Mrs. Roosevelt's Keene appearance.

Six

SPECIAL EVENTS AND LEISURE ACTIVITIES

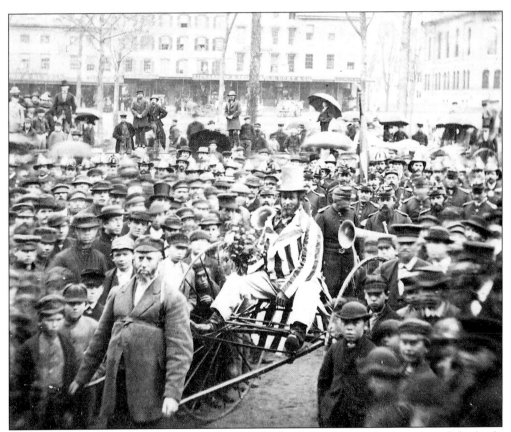

Paying a political bet, 1872. John Drummer and John Fisher bet on the outcome of the hotly debated 1872 presidential campaign battle between Ulysses S. Grant and Horace Greeley. The local newspapers covered the campaign, and the bet, for weeks in advance, generating widespread local interest. Grant's victory inspired a 100-gun salute by local Republicans. On Thursday, November 14, a large crowd gathered in Central Square to see the terms of the now famous wager fulfilled. Drummer, the winner, dressed in a suit made from an American flag and mounted a sulky. Fisher, the loser, pulled the two-wheeled carriage from the Square to the fairgrounds and back, accompanied by the crowd and the Keene Brass Band.

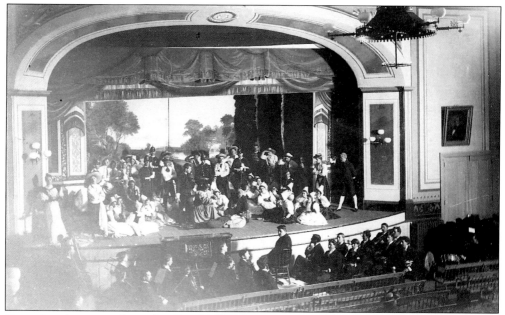

Evangeline drew crowds to the City Hall auditorium in March 1896. The local cast of one hundred characters included members of the Keene Light Guard. Plays, concerts, and lectures were extremely popular events in the era before radio and movies.

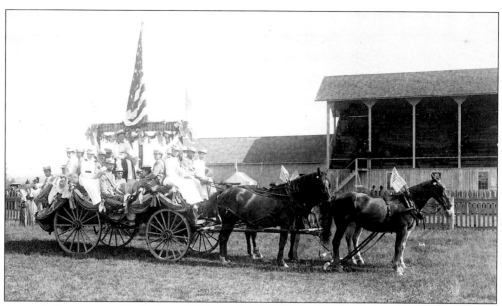

A parade float prepared by Sullivan's "Honor Bright" Grange on display at the Cheshire County Grange Fair, September 1891. These annual fairs were held at the Keene Driving Park. Founded to promote the interests of agriculture, the Grange was a popular and important organization at a time when thousands of farms operated in the region.

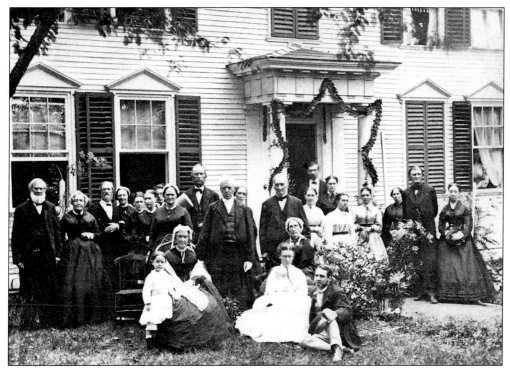

The golden wedding anniversary celebration of Zedekiah and Elizabeth Barstow at their home, the former Wyman Tavern, in 1868. Zedekiah Barstow served as pastor of the Congregational Church for half a century. The fact that there was nary a smile in the assemblage probably derived from the tedious photographic process rather than the temperament of the subjects.

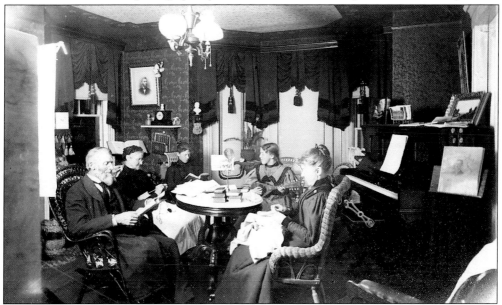

The J.A. French family at home, c. 1890. Three generations of this Keene family were relaxing in their finely appointed Victorian parlor. Leisure time pursuits in this household included sewing, reading, knitting, viewing photographs, and playing the piano and the ukelele.

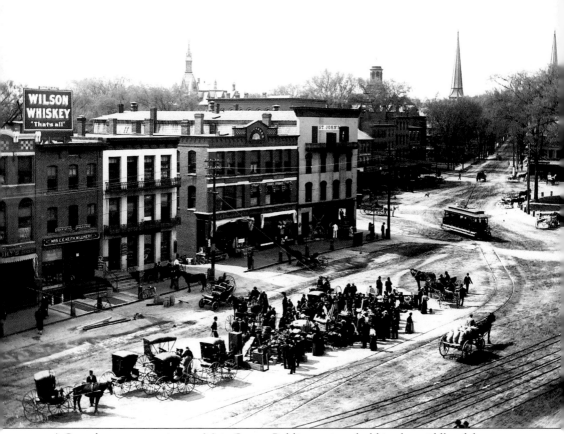

A Saturday street auction on Main Street. Public auctions held in the middle of the street were a tradition for many years. While a crowd had gathered to bid and buy, many others carried on normal business on Main Street. This view of furniture piled in the street betokens a slower pace of life, and of traffic. It may also denote another hill farm abandoned or foreclosed on. This photograph was taken prior to 1910.

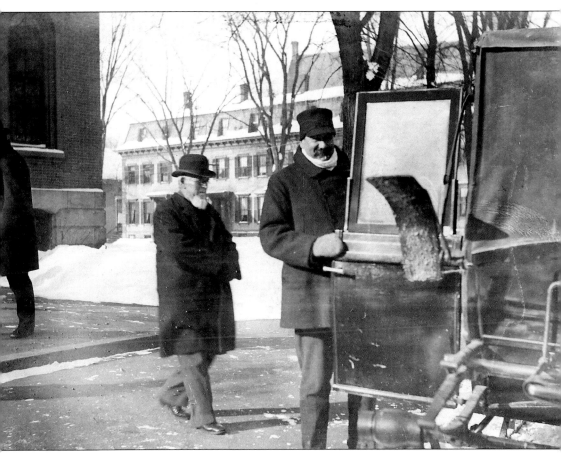

Malachi Barnes (center) leaving the Cheshire County Courthouse after receiving a sentence of life in prison for murder. Barnes had been tried for the murder of Asahel Dunton, who had boarded at the Barnes home in Sullivan. Barnes attacked Dunton and Mrs. Barnes with a bark peeler on September 19, 1903, presumably in a jealous rage; Mrs. Barnes and Dunton had dug potatoes together earlier in the day. Dunton died at the hospital in Keene three days later, and Malachi Barnes was convicted of his murder in January 1904. This rare crime-related photograph depicts the outcome: Sheriff Will Tuttle (left) returns to the courthouse as Hiram Houghton waits at the door of the waiting sleigh to transport Barnes to prison.

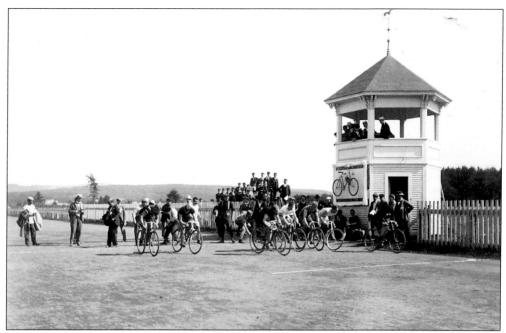

A bicycle race at the Keene Driving Park. This contest probably took place in the late 1890s at the peak of the bicycle craze. Eight racers vied for the grand prize, probably the new Wilkins Toy Company bicycle that hung from the observation stand. This well-organized event included accompaniment by a brass band.

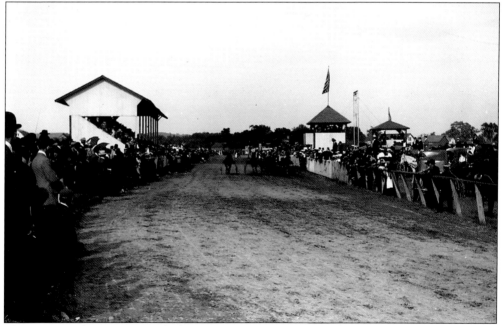

This race at the Driving Park featuring trotters drew a much larger crowd than did the bicyclists. Despite the popularity of race competitions—whether horses, bicycles, trotters, or eventually early autos—photographs are rare, perhaps because of the difficulty of capturing rapid movements on early film.

A Boston Commercial Club eight-day tour of New England arrived at Keene on June 11, 1912. The group was greeted by a delegation of local residents at the Cheshire House. Early auto tours often combined business and pleasure, publicizing tourism and the New England Hotel Association, of which the Cheshire House was a member.

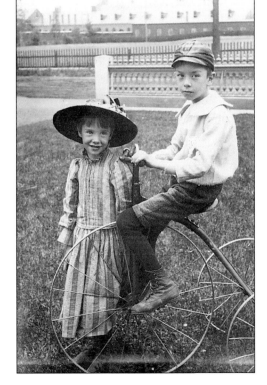

Margaret and Ralph Whitcomb enjoying a day of play on West Street in the mid-1890s. Elaborate children's toys, such as this wonderful Victorian tricycle, illustrate the increased purchasing power of the middle class. The railroad repair shops dominated the horizon.

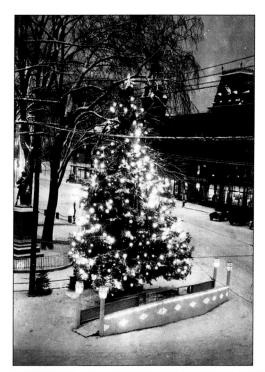

The "Bridge of Joy" was a holiday tradition in Central Square. The city government and local civic organizations sponsored this event, whereby needy children would walk across the "bridge" to receive a gift from Santa Claus. This photograph dates from about 1920.

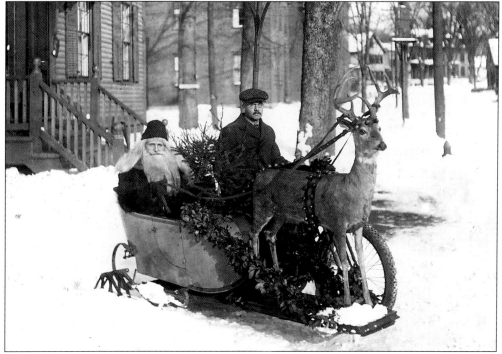

Santa Claus and his reindeer pose on Mechanic Street before making an appearance at a community Christmas tree observance around 1920. John Chapman dressed as Santa and settled into the converted sidecar of this "Majestic" motorcycle before taking to the snowy streets.

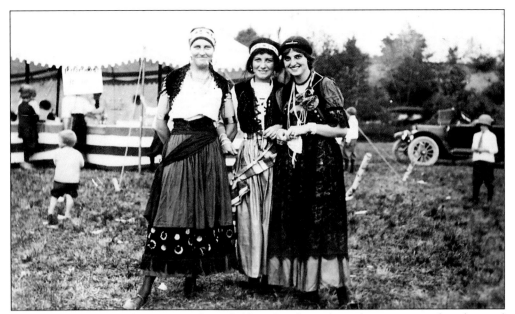

Grace Fowler Newcomb, Kitty Smith, and Alice Goodnow dressed up as gypsies for a hospital fund raiser in 1921. The fair, featuring exotic dancers, freaks of nature, and a parade, was a success, as was the hospital campaign itself. The result was a modern sixty-bed medical wing at the Elliot Hospital.

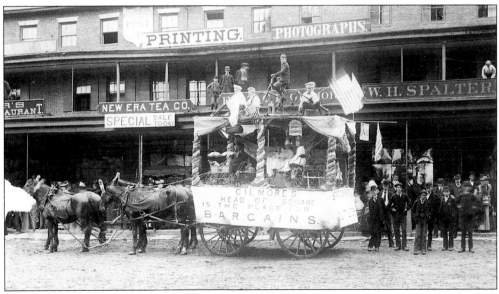

This Gilmores' store parade float featured toys available at the store, and the children who longed for them. Charles Gilmore, whose printed advertising featured sleds, rocking horses, wagons, doll carriages, bicycles, tricycles, velocipedes, toys, and novelties "of every description," also publicized his business with elaborate parade floats in the late 1880s.

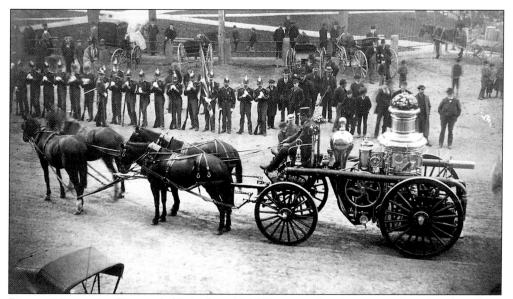

Fireman's Inspection Day, probably in the mid-1880s, soon after the city purchased an Amoskeag steam fire engine. Inspection Day events included a parade, contests, fire house tours, a catered dinner, and climaxed with a Firemen's Ball in the evening.

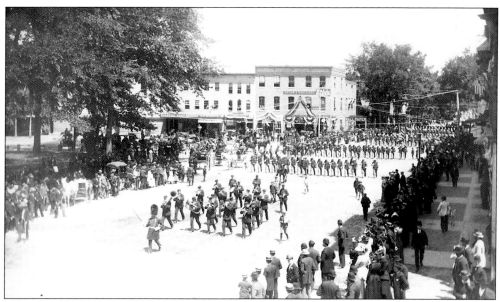

A brass band led a parade down Washington Street and into Central Square. O.P. Murdick's Ice Cream Parlor must have done a brisk business on "parade day" one hundred years ago.

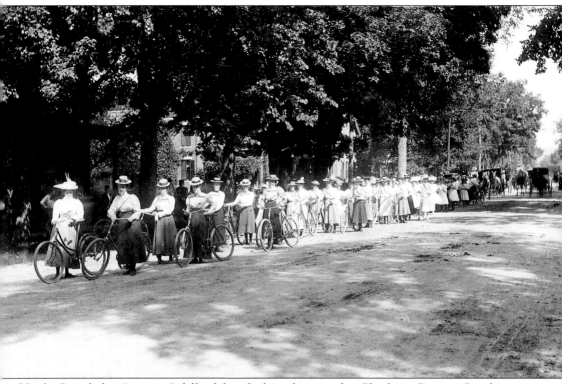

Uncle Sam led a "country" full of female bicyclists in the Cheshire County Coaching Parade of 1898. Each woman bore the name of a different state on her blouse. Such a demonstration presaged the increased mobility and freedom which women would realize in the World War I era.

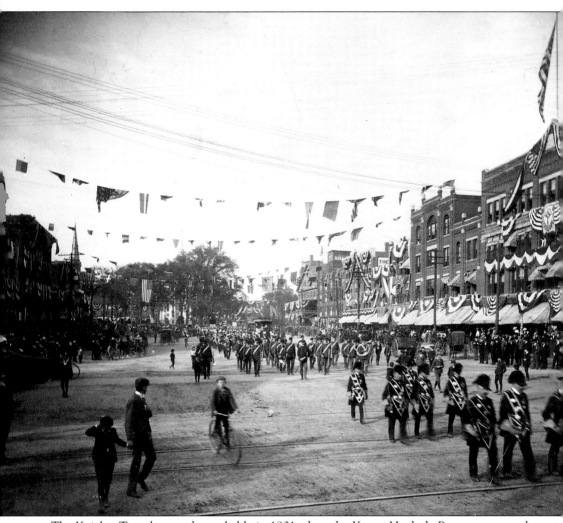

The Knights Templar parade, probably in 1901 when the Keene Hugh de Payens commandery hosted a twin-state lodge and convention. The population of Keene had recently surpassed the 9,000 mark, but the thousands of people, hundreds of banners, dozens of suspended electric lines, and three railroad tracks gave the feel of a much larger city. Although it was small by national standards, the city had become the unrivaled social and economic center of southwestern New Hampshire.

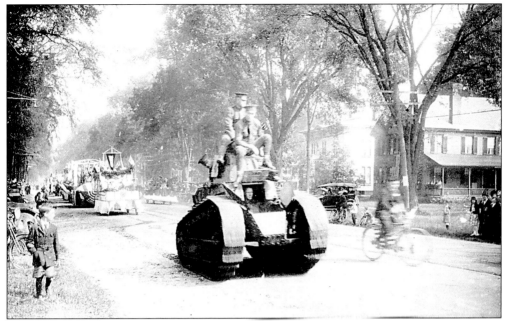

The sight of a World War I tank on Main Street must have amazed the youngsters lining the roadside. This vehicle symbolized the military power and success of the United States on the occasion of Armistice Day. This was more than just a parade—it was a national celebration.

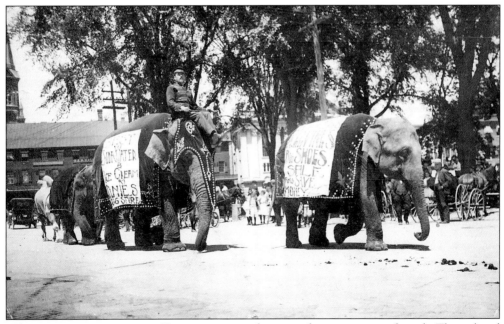

"The circus is coming to town!" was a joyous exclamation for generations of youth. The railroad enabled traveling circuses to visit small towns such as Keene. For almost a century these shows offered incomparable entertainment. The elephants with this 1920s show served as moving billboards as the circus parade rounded Central Square.

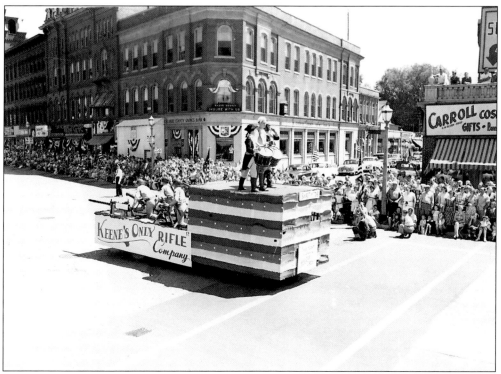

A Keene bicentennial parade float, 1953. The 200th anniversary of the granting of the township was observed with a week-long celebration. Events included dances, exhibits, fireworks, contests, plays, an airshow, and a visit from Miss America Neva Jane Langley.

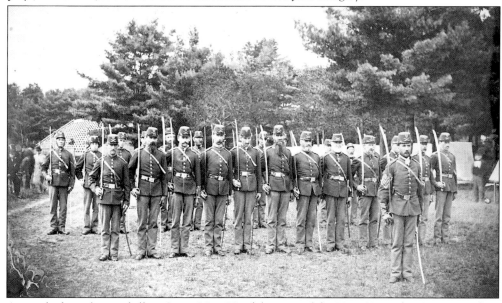

A squad of cavalry on drill at Camp Natt Head (so named for New Hampshire's governor) in 1879. The Keene Light Guard Battalion hosted the New Hampshire National Guard at this four-day encampment at the Cheshire Fairgrounds (now Wheelock Park). Guard units such as these served as the local military presence for several decades after the Civil War.

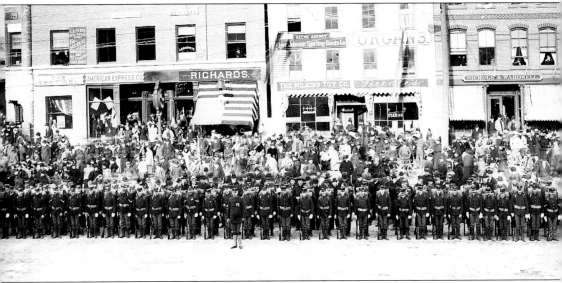

The Keene Light Guard answered the call for service following the sinking of the battleship *Maine* in Havana harbor early in 1898. On May 7 Captain Paul Babbidge (front center) and the local contingent of the New Hampshire National Guard paused for a group photograph before boarding a train and moving off to war. Babbidge commanded the 110 men of Company L of the First Regiment of New Hampshire Volunteers. The troops returned following the end of hostilities four months later without having seen action. The store fronts along Main Street illustrate a changing American lifestyle and business climate at century's end. Leisure time was becoming more prevalent and a business commodity. An early Keene "travel agent" advertised railroad and steamship tickets. Beedle sold pianos, Wilkins offered toys, and the Iver Johnson company retailed "sporting goods."

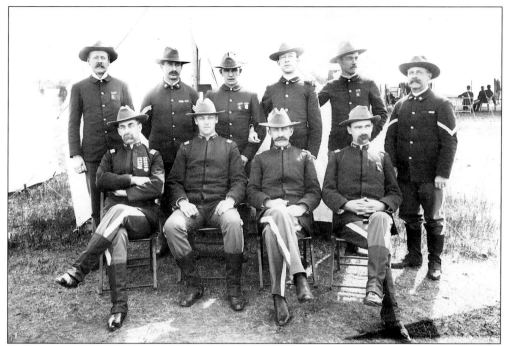

Another contingent of the Keene Light Guard. This dignified group included residents from all walks of life. Among these ten were carpenter Byron Robertson, chairmaker Elwin Johnson, store owner Edward Gustine, factory overseer Eugene Keyes, box manufacturer Carl Reed, and textile mill owner John Colony.

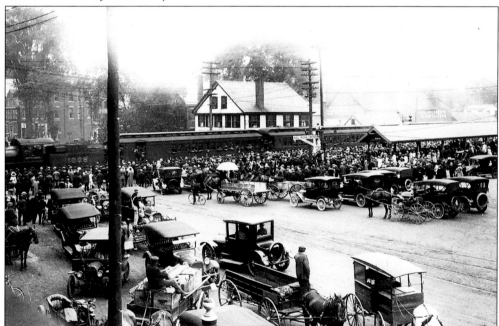

Keene's National Guard troops mustered and boarded a southbound train once again on June 20, 1916, this time to engage in the Mexican border dispute. Notice how disproportionately autos outnumber wagons on Main Street.

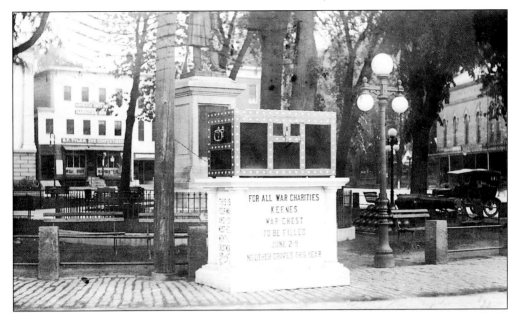

Keene's "War Chest" for World War I charities allowed civilians to support soldiers, and the families of soldiers, who were fighting thousands of miles away. Modern communication and transportation had drawn the world's governments and economies closer together, making it necessary for the United States to defend democracy by fighting on a distant continent. Six hundred Keene people served in the war.

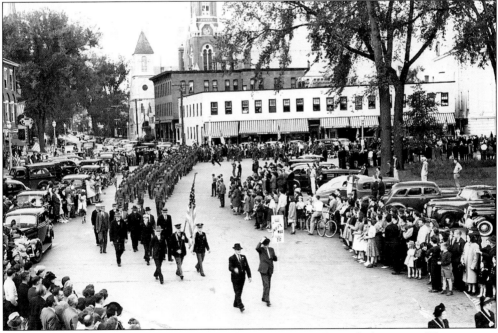

The farewell parade for Battery G, September 1940. Two Spanish-American War veterans walked the same route that they had traveled in 1898 as they led the local National Guard battery around the Square and to the railroad station in 1940. This coast artillery contingent was activated in anticipation of World War II.

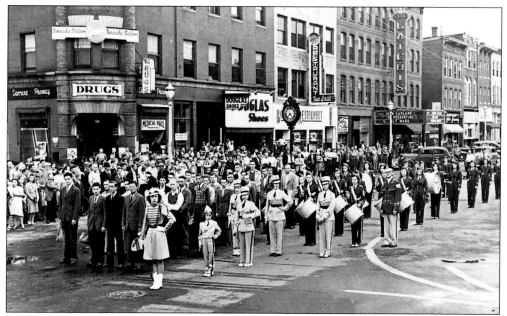

This group of World War II "selectees" left Keene in July 1943, following in the footsteps of many previous local residents who boarded trains at the station to go to war. Modern technology enabled war on a truly worldwide scale; Keene civilians now feared air raids by planes from distant lands.

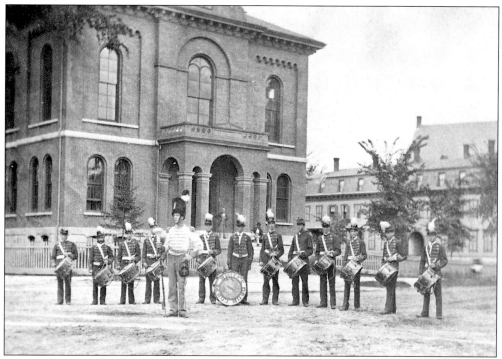

White's Drum Corps in front of the courthouse, 1877 or 1878. Town, private, and organizational bands have been a Keene, and New England, tradition for many years, as well as an important source of local pride and entertainment.

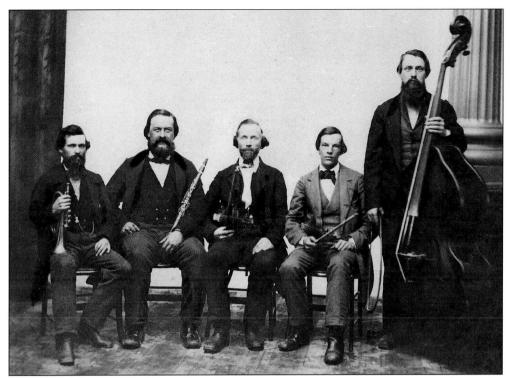

An early Keene dance orchestra, *c.* 1860. Bands such as this played at the extremely popular and numerous local balls and cotillions. This photograph was the last of this group's cornetist, Henry Harvey Wilcox (far left), who died soon after this picture was taken.

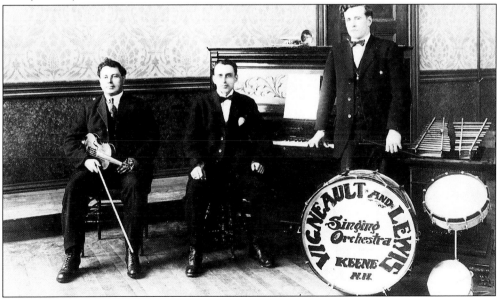

The Vigneault and Lewis Singing Orchestra played at the Easter Monday Ball on April 17, 1911. Store clerk Henry Vigneault and post office clerk Harry Lewis became central figures in Keene's musical scene. Vigneault opened Vigneault's Melody Shop music store and Lewis became manager of the Keene City Band.

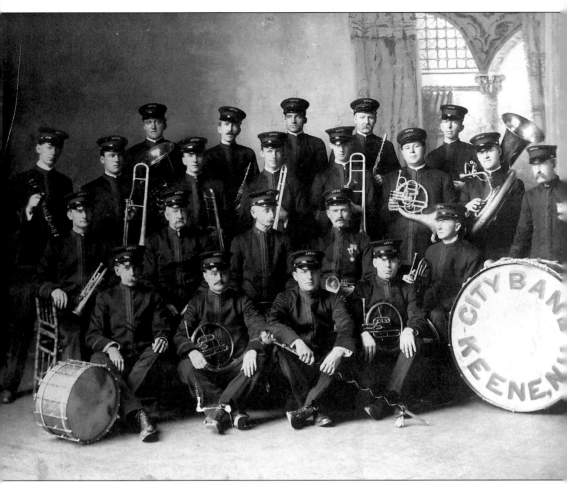

The Keene City Band, probably during the 1890s. This was one of the most successful bands in the region, celebrating its 100th anniversary in 1955. Composer and bandmaster Edwin E. Bagley (second row center) composed the "National Emblem March," one of this country's most popular military marches. Town bands still perform in parades and at summer festivals today.

Seven

DISASTER!

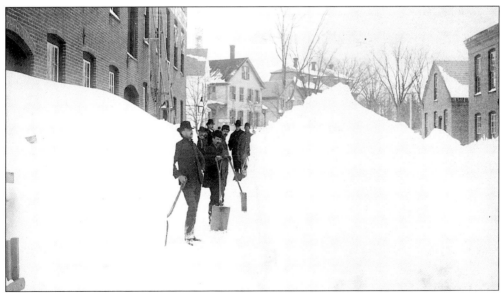

Clearing Mechanic Street after "The Great Storm" of March 1888. The Blizzard of '88 is the storm by which all other New England storms are measured. The three-day storm left 36 inches of snow on the ground in Keene; gale force winds whipped the accumulation into 15-foot drifts. Roads and rail lines were impassable for days. Local residents had to shovel out of their houses or leave their homes through second-story windows.

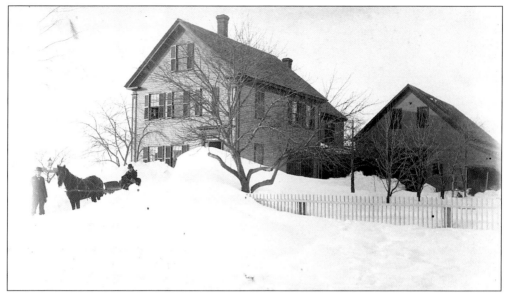

Zebina Graves' residence in West Keene the day after the Blizzard of 1888. The storm resulted in 400 deaths and $20 million in damages throughout the Northeast. The Graves' largest drift was in the middle of the driveway.

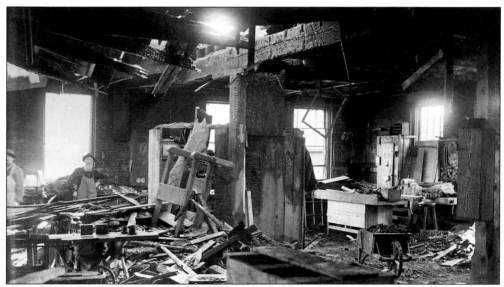

The aftermath of the fire at the Keene Furniture Company, June 1896. This fire closed down temporarily one of the six furniture factories in Keene producing hundreds of thousands of chairs annually, making Keene the "porch rocker capital of the United States." Horse-drawn hose carts and ladder wagons were a vast improvement over bucket brigades, but were still far inferior to the modern fire fighting equipment that was developed a few decades later.

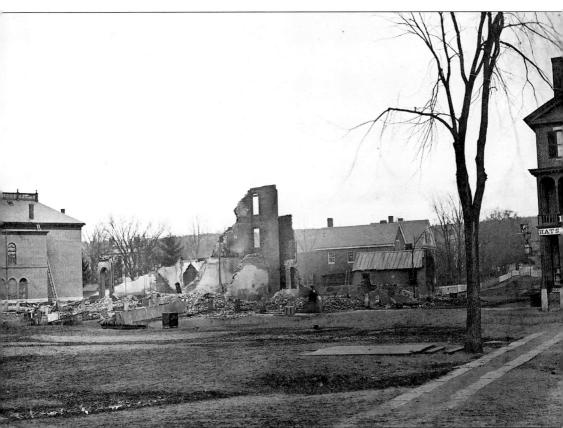

The east side of Central Square following the fire of October 19, 1865. This was one of the most destructive fires in Keene history, destroying the entire east side of the Square. The fire companies nearly had the fire under control when the town well went dry. The Cheshire House, the Town Hall, and adjacent buildings were saved, but all of the business blocks on the east side of the Square were destroyed within three hours. For several years previous there had been debate over piping water into the village. This devastation at Central Square resulting from water shortage terminated the debate; a water system was built from Goose Pond to downtown in 1869.

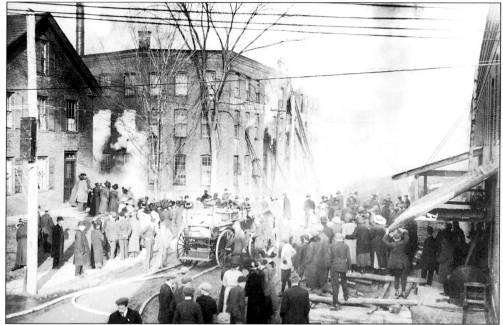

One of the fires at the Impervious Package Company, 1913. This firm produced wooden pails and cans that were impervious to oil, kerosene, and other liquids. Large quantities of wood and sawdust created serious fire hazards, causing three devastating fires for this firm. The Keene Fire Department purchased its first motorized fire truck within four years of this photograph.

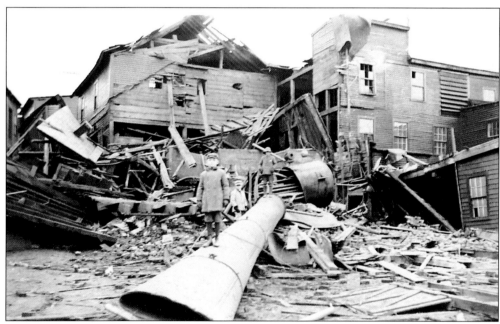

The boiler explosion at the Keene Glue Company. This midday explosion in 1912 completely demolished the boiler house of this forty-year-old Keene firm. Bricks, pipes, and timbers were strewn over the four-acre site, but amazingly no one was injured in the blast. The enormous devastation presumably deterred waggish comments about the building coming unstuck.

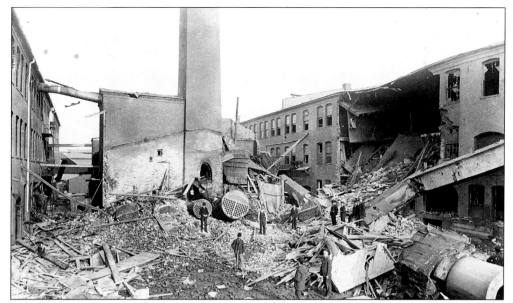

This blast at the Beaver Mills industrial complex occurred at lunch time on May 22, 1893, killing three men and injuring five others. The explosion flattened the boiler house, blew a 50-foot hole in the wall of the adjacent factory building, and threw bricks more than two blocks away. Such explosions were quite common before workplace safety rules were established for industrial power plants.

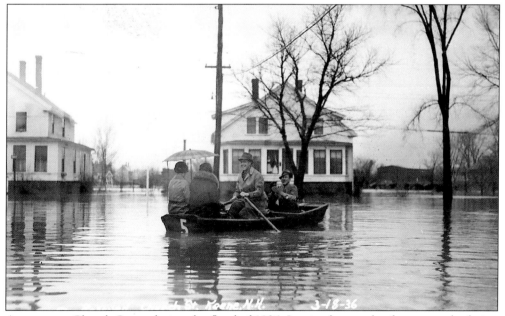

A rescue on Church Street during the flood of 1936. It rained every day for two weeks during March 1936. In addition to the 10 inches of rain, the 12-inch snow cover melted, flooding all low lying streets in the city. The Ashuelot River rose 3 feet.

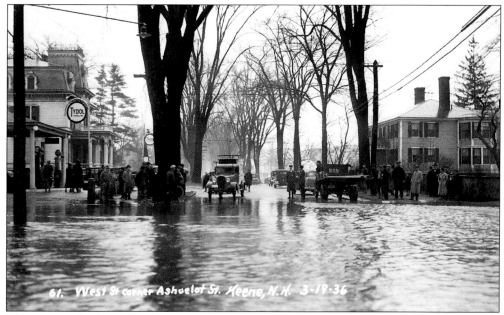

The rising Ashuelot River threatened the Faulkner home (right) and Colony home (left) on March 19, 1936. Keene had always been susceptible to flooding because of its location in a valley crisscrossed by rivers and streams. This flood and the devastating hurricane-related flood of 1938 provoked construction of flood-control dams upstream from the city.

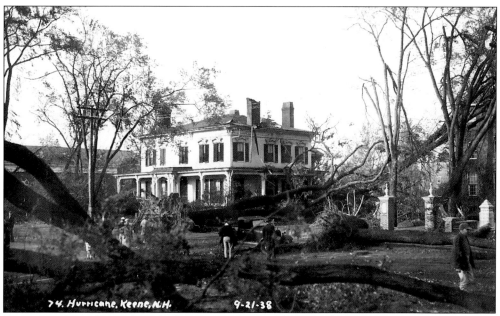

Damage on Main Street from the hurricane of 1938. The most devastating storm in the region's history severed communication with the outside world and caused $1 million of damage in Keene. This view of the president's residence at the Keene Teachers College shows some of the 2,000 shade trees which were destroyed in the city by the September storm.

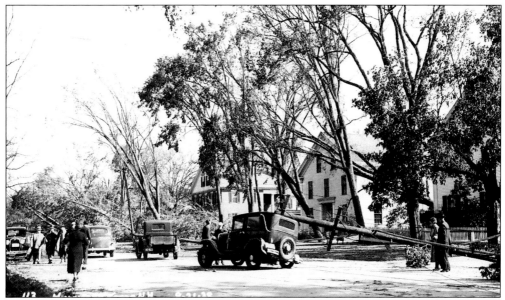

The driver of this auto may have seen the pole coming as it toppled toward his roof on Washington Street, but the residents of Keene had no warning that a hurricane was about to strike in September 1938. Cars were crushed, steeples toppled, roofs blown off, and three hundred people evacuated from their homes.

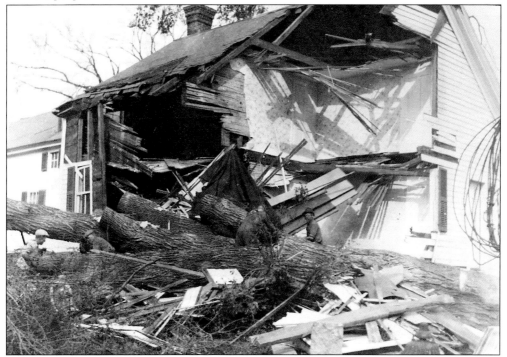

This home on the corner of Union and Green Streets was severed by the large tree in the foreground during the hurricane. Several homes and businesses experienced extensive damage. Despite the unprecedented damage caused by the high winds and 6 inches of rain, not one local resident was seriously injured by the famous hurricane of September 1938.

ACKNOWLEDGMENTS

A book is rarely the work of one person. That was certainly true of this publication.

It was a difficult, and sometimes painful, task to select two hundred photographs for publication from a collection of several thousand. I am grateful to Historical Society of Cheshire County President Richard Scaramelli and curatorial assistant Marie Ruffle for assisting with the selection process. Both of these people served dual roles in the preparation of this work. Marie Ruffle also spent many hours researching the historical background of many of the photographs, while Richard Scaramelli generously accepted the responsibility of critiquing the text.

A special thank you goes to Roxanne Roy, who served as typist for the project. She remained cheerful throughout, despite having to decipher my handwriting and deal with constant revisions.

This book would not have been possible without the photograph collections of the Historical Society of Cheshire County. This active Keene-based organization is the only county historical society in New Hampshire. The organization collects, preserves, and communicates the history of all twenty-two towns and one city in the county. I express my appreciation to the Society's board of trustees for its enthusiastic support of this project.

A final expression of gratitude goes out to two other groups of people. I acknowledge the generosity of the many donors who contributed these photographs to the Historical Society over the last seventy years. Finally, thanks goes to the local historians who have worked diligently during the last two centuries to record the history of the community. Their work allows us a much more complete understanding of the images preserved in these historical photographs.